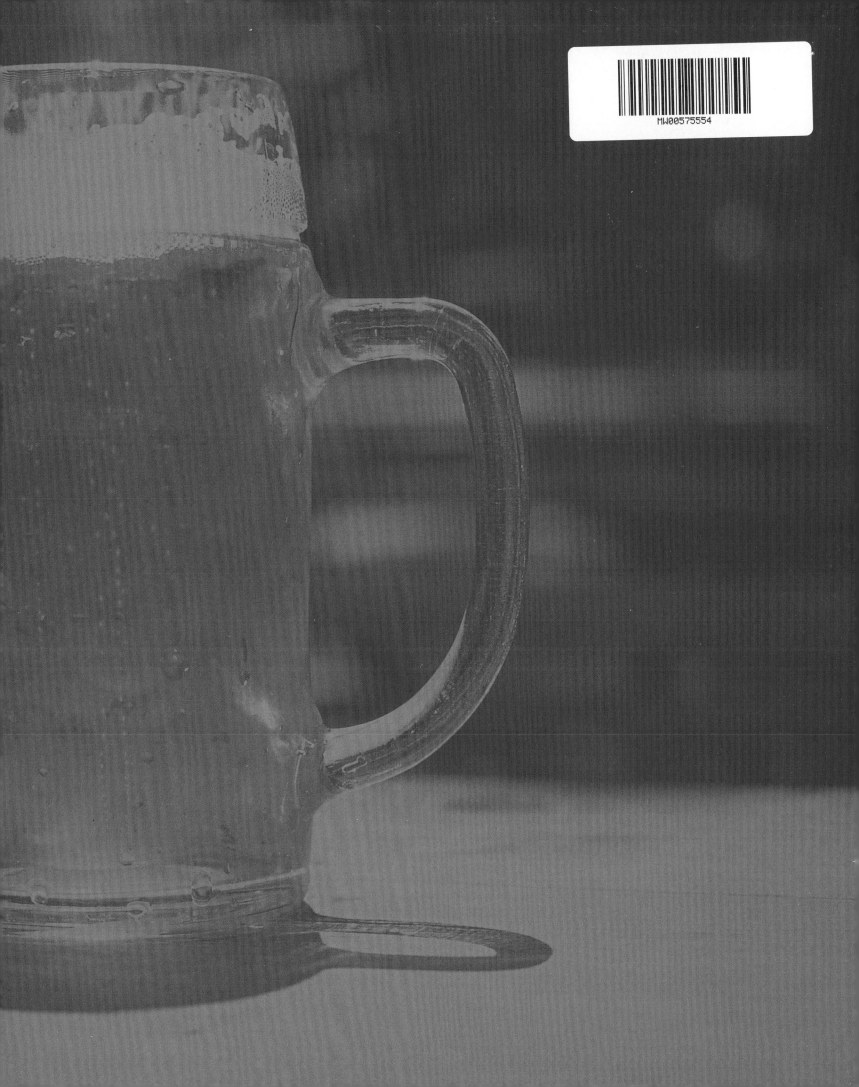

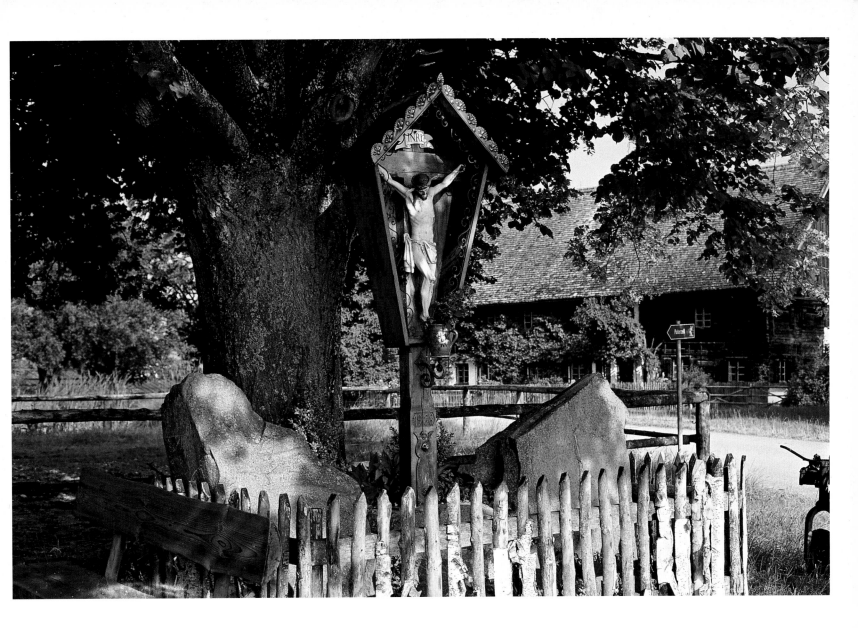

FASCINATING

BAVARIA

PHOTOS BY

MARTIN SIEPMANN

TEXT BY

ERNST-OTTO LUTHARDT

FLECHSIG

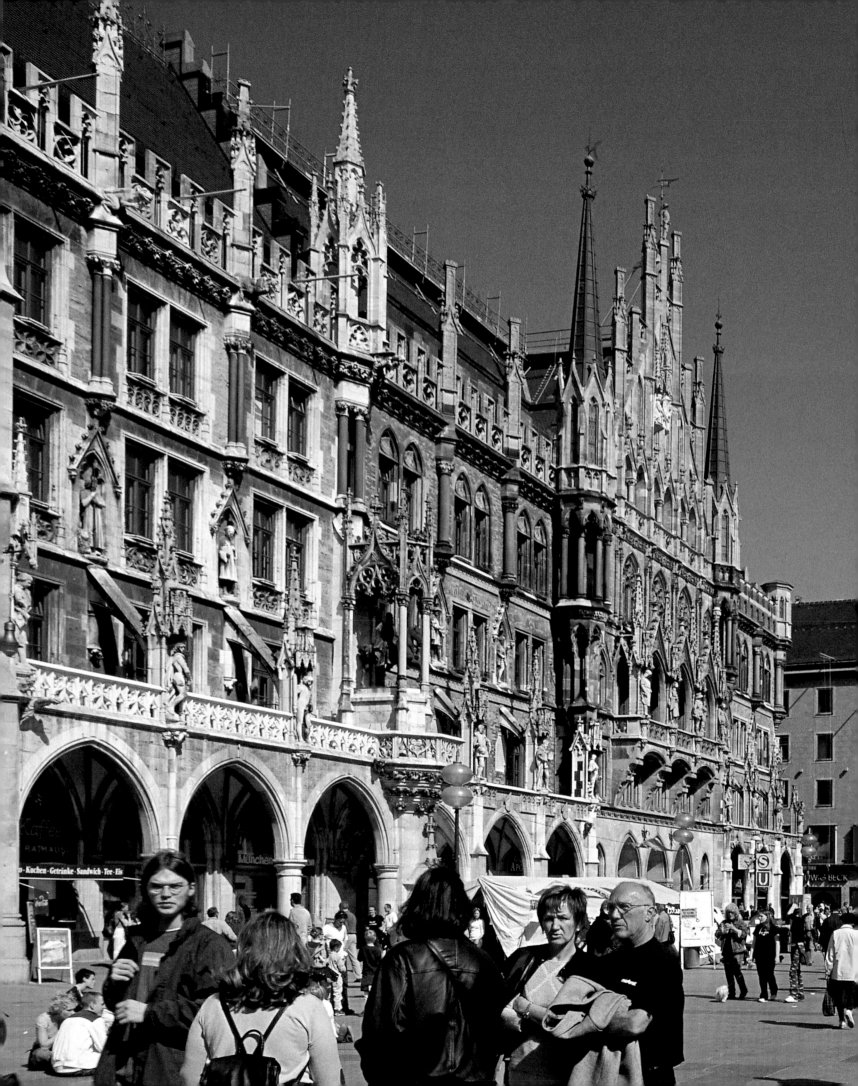

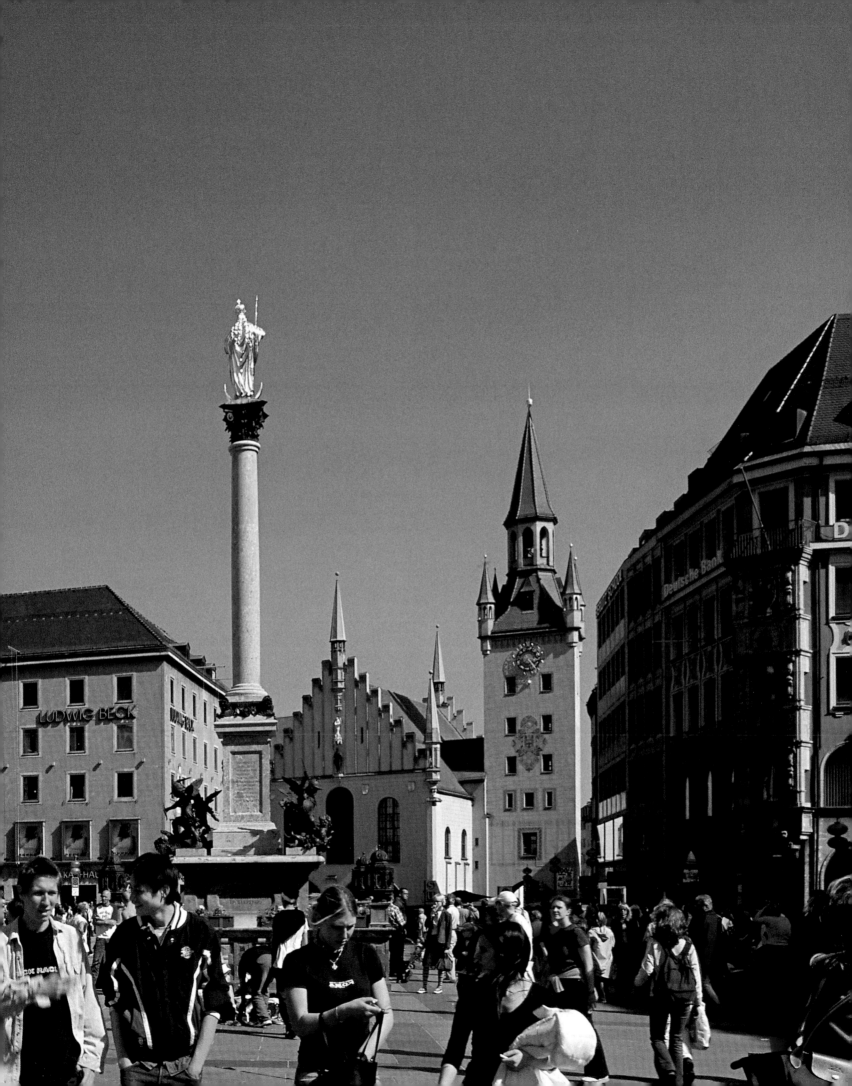

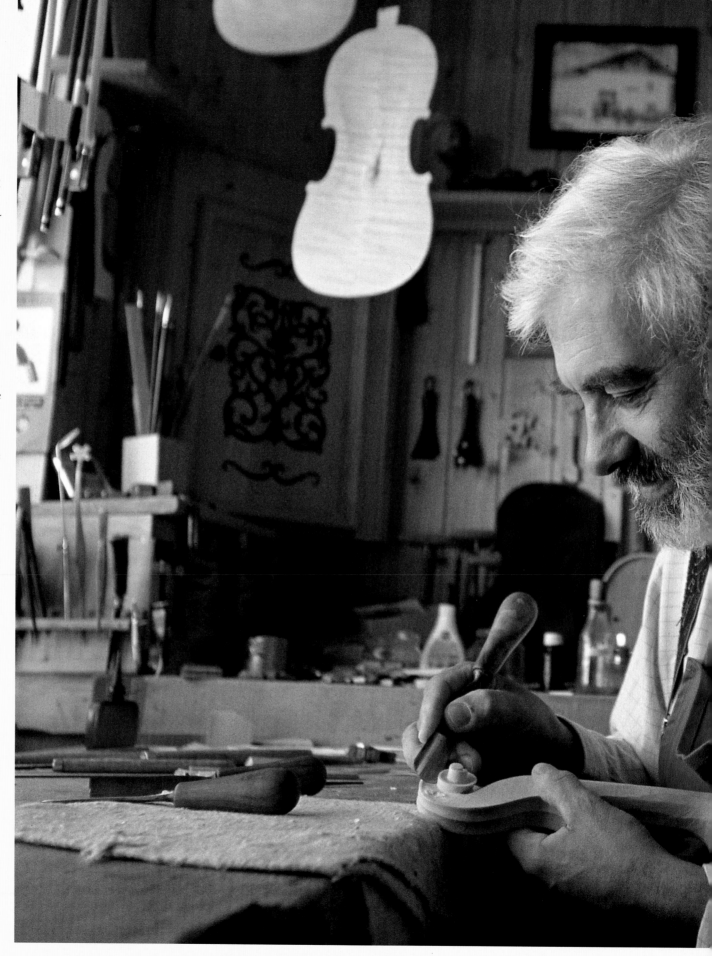

First page:
This linden tree with its
splendid crucifix is in the
village of Schlitten.
Its famous and equally
enormous counterpart,
the Tassilolinde at nearby
Kloster Wessobrunn,
has a circumference of
13 metres (42 feet).

Previous double spread:
The heart of Munich's old
town beats on Marien-
platz with its famous land-
mark: a pillar crowned by
a gilt statue of the Virgin
Mary, the patron saint of
Bavaria. Near it is the
Altes Rathaus (right) and
the neo-Gothic Neues
Rathaus.

Right:
Violins have been made in
Mittenwald since the end
of the 17th century. There
is also a state academy
here where the next
generation of instrument
makers is trained. Famous
masters of the art include
Anton Maller, depicted
here at work.

Page 10/11:
The Zugspitze in the
fading evening light. While
Germany's highest peak
captures the last rays of
sunshine, further east
the Wetterstein Range is
already cloaked in darkness.

CONTENTS

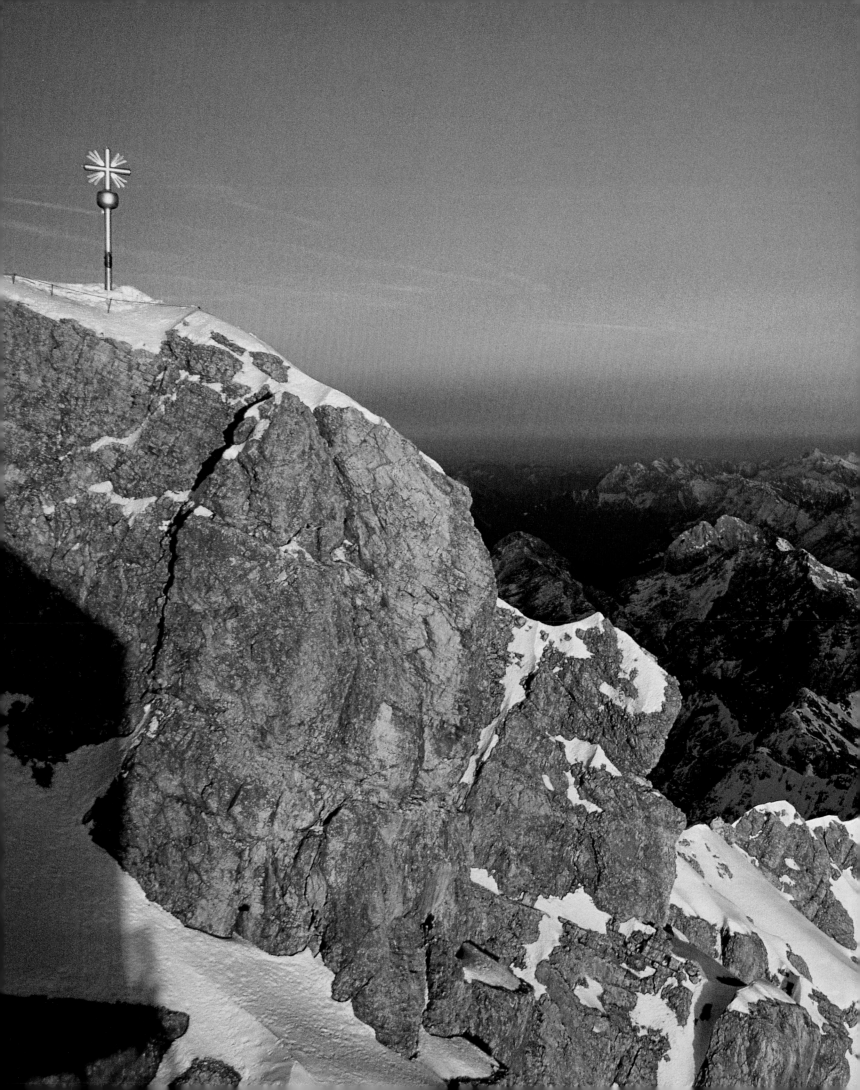

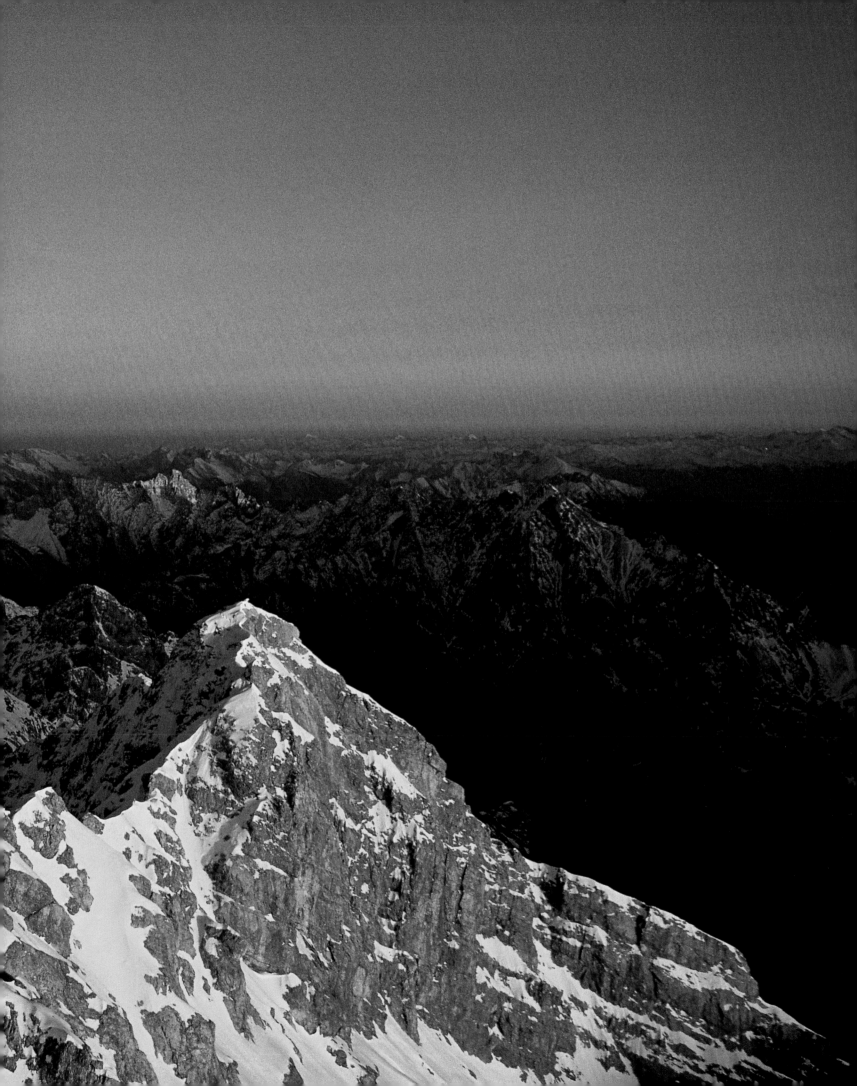

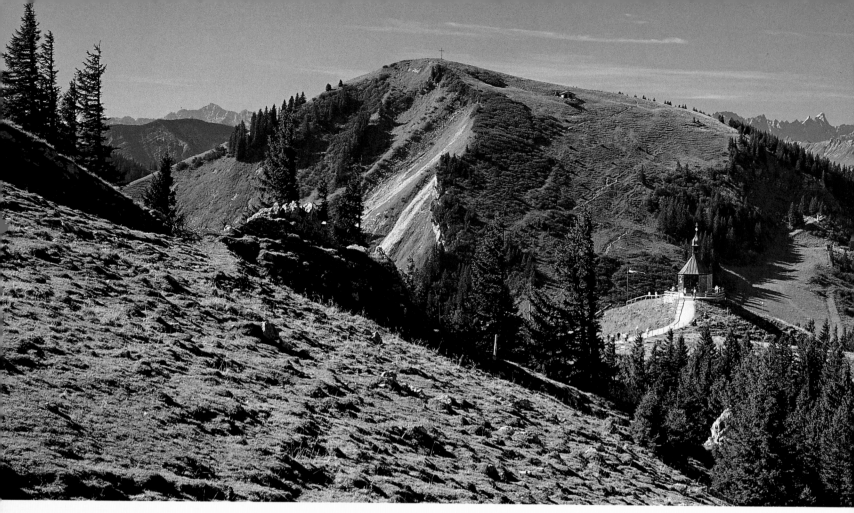

GERMANY'S MOST POPULAR HOLIDAY DESTINATION – BAVARIA

The first inhabitants known to us to settle between the River Danube and the Alps were the Celts. They moved into the area during the 8th century BC and were conquered by the Romans 15 years before the birth of Christ. During the migration of the peoples the Celto-Roman population was infiltrated by Germanic tribes. The new ethnological melting pot was soon given the name "Baiuvarii", the first rulers of whom were the Agilolfing dynasty. They were succeeded by the Carolingians, the Luitpoldings, the Salians and the Welfs. In 1180 the Wittelsbachs came to power and remained firmly ensconced as local potentates for almost 750 years. Their period of rule is marked not only by success on the battlefield but also by many remarkable acts of peace. The "democratic and social republic of Bavaria" was founded on November 7, 1918. In 1933 the free state was forced to cede its sovereign rights to the Third Reich, only having them returned at the end of the Second World War. In 1946 the people of Bavaria passed a new constitution – their third – and three years later Bavaria became part of the Federal Republic of Germany.

The fairytale prince

The most famous monarch of Bavaria was King Ludwig II, the man who lived his life as a fairytale. Born in 1845 he was catapulted to the throne on the death of his father at the tender age of 18. He hated the endless games and intrigue of politics and quickly retreated into his own land of make-believe, characterised by the legends of Lohengrin, Tristan and Tannhäuser. His disregard for financial concerns led to his being accused of ruining the country and declared insane. On Whit Sunday 1886 he and his psychiatrist went for a stroll on the Starnberger See. Four hours later their bodies were found washed up on the shore. The water at that point was as shallow as many of the official reasons given for the king's untimely demise. Ludwig II lives on, however, in his castles and palaces, the most famous of which is possibly Neuschwanstein, originally conceived as a small hunting lodge erected on the ruins of an older castle and now an orgy of Romantic neo-Gothic. Ludwig's plans for the Herreninsel in the Chiemsee were on an even grander scale; his palace of Herrenchiemsee was to be the next Versailles. Schloss Linderhof, the third of his projects, is positively modest in comparison.

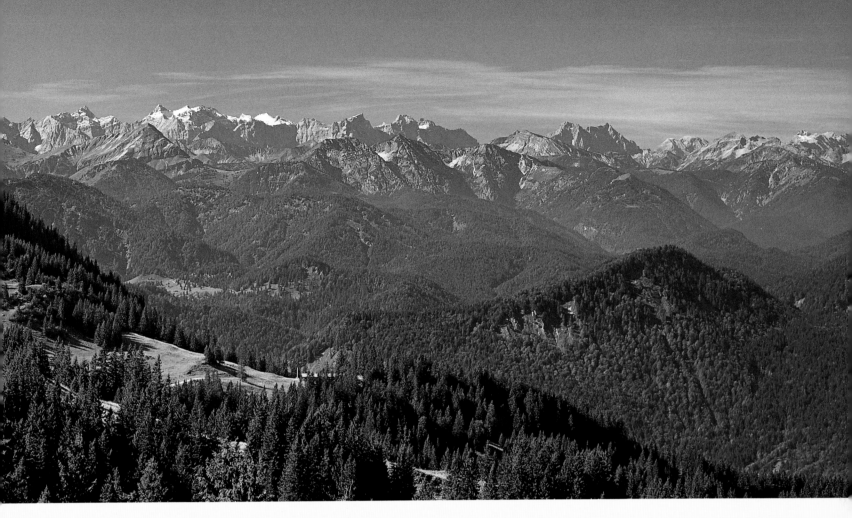

The Wallberg (1,722 m / 5,650 ft) in the Mangfall Range and the slightly higher Risserkogel block off the Tegernsee Valley to the south. Beyond the Setzberg the crags of the Karwendel Range pierce a blue-and-white Bavarian sky.

The biggest funfair in the world

It all began on October 17, 1810, with a simple race held to celebrate the wedding of the then crown prince and later king Ludwig I to Therese von Sachsen-Hildburghausen. Unlike the marriage the races turned out to be a rip-roaring success. In 1811 an agricultural show pitched its tents alongside the race track. The first swings appeared in 1818. Just two years later merry-go-rounds materialised, accompanied by various sideshows, exotic exhibits and entertainers. Alleged wonders of the world were put on display: five-legged calves, oxen with two tails, women without lower bodies, Siamese twins and hairy lion men. There were flea circuses, musical sea lions and dancing Negroes. Today the sensations are of a very different nature; big dippers and other high-tech rides make you dizzy just to look at them. Munich's Oktoberfest stands for the latest in state-of-the-art fairground attractions. There are also still beer tents aplenty, now comfortable affairs of massive proportions. And the waitresses dashing from bar to bench hour after hour, wielding ten heavy litre Steins of beer, are also very much part of the *Fest*. In 1910 the German Abstinence League demanded that women be banned from the profession for moral reasons; one can hardly imagine what the Oktoberfest would be like had their agenda had proved successful.

Monastic Bavaria

The people of Bavaria had their first brushes with Christianity at the end of the 6th century AD; a few decades later the great missionaries arrived in Emmeram and Rupert, Korbinian, Willibald and Kilian. In 738/39 Boniface founded the bishoprics of Regensburg, Passau, Salzburg and Freising. This was also when the first monasteries arose. The Benedictine monastery of Wessobrunn in particular is famous for its *Wessobrunn Prayer* from 814 which marks the beginning of German literature. The medieval poets, scribes and illuminators were followed by the scholars and stucco artists of the 18th century. The Zimmermann brothers especially created works of outstanding merit, the most beautiful of which is the Wieskirche in Steingaden, now a UNESCO World Heritage Site.

There are other Bavarian literary milestones of renown. The first work of true fiction, a Latin epic in verse entitled *Ruodlieb*, was penned at the monastery of Tegernsee in the mid 11th century; 100 years later one of the most beautiful love poems of all time (*Dû bist mîn, ich bin dîn...*) was discovered in the correspondence of another Tegernsee monk called Werinher. In 1803 a manuscript of medieval vagabond poetry was found at Kloster Benediktbeuren; put to music by Carl Orff in 1937, as *Carmina Burana* it has become one of today's most popular pieces of classical music.

The call of the Alps

For a very long time the northern territories of the Alps were *terra incognita* where dragons and other evil creatures were said to dwell. One of these was the legendary King Watzmann who terrorised the land with his brutal and savage wild hunts. None other than the Good Lord himself was

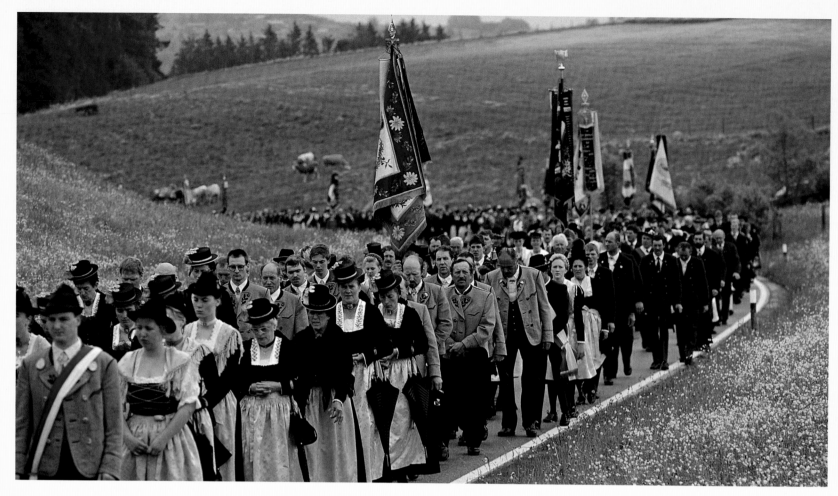

able to stop the despot, turning him and his family to stone in a fit of supreme wrath. This act of God proved both beneficial to Watzmann's contemporaries and his successors; the Watzmann Group is undoubtedly the most impressive massif in the German Alps. Yet the king continues to hold his head up high and give all those who approach him the cold shoulder; there is no other mountain precipice in this part of the Alps higher or more dangerous than the east face of the Watzmann with a sheer drop of 2,000 metres (ca. 6,500 feet).

Unlike the inhospitable Watzmann the Zugspitze in the Werdenfelser Land in the heart of the Bavarian Alps is definitely more user friendly. Year in, year out over half a million visitors are comfortably transported to the summit of Germany's highest peak by no less than four mountain railways, one of them in Austria.

The Bavarian capital

There are few towns which can match the bold self-confidence of Munich, the city of the muse. The Alte and Neue Pinakothek or new Pinakothek der Moderne, the Glyptothek and Städtische Galerie at the Lenbachhaus: all of them are counted among the world's most famous hoards of artistic treasure. Architecture and design have also left their distinctive mark on the elegant capital, the products of which include the residential palace, the baroque Asamkirche and the palatial dwellings of Schleißheim and Nymphenburg. One of Munich's other unique features is the huge green oasis which sprawls across its middle;

no other European capital can boast as large and central a park as the Englischer Garten. And there is also no other Continental museum of technology with so broad a range of exhibits and such popular facilities (including the Planetarium and IMAX cinema) as the Deutsches Museum. Yet the city's biggest plus is the charming and winsome manner in which it presents itself.

How to make money

The Fugger family from Augsburg were a prudent bunch; among the first to follow the sign of the times, they took a number of chances which led to fame and fortune. The most successful of the dynasty was Jakob the Rich who in 1505 began importing spices from East India to Europe and set up the biggest copper trade in the world. As he was party to all of the big financial operations of his day, he was not only able to control the flow of his monies but also bring influence to bear on kings and emperors. Despite his vast wealth Jakob did not neglect his responsibilities as a human being. A strict Catholic, he befriended and supported the Humanists, for example, who placed the human sciences above the divine. In 1521 he also initiated a social project on an unprecedented scale which provided "poor, hard-working citizens" with 106 homes with all the 16th-century mod cons. Bavaria's first council estate, the Fuggerei, still exists, which just goes to show how ahead of its time it was and how important it is to make money work not only for profit but also for the good of the people.

14

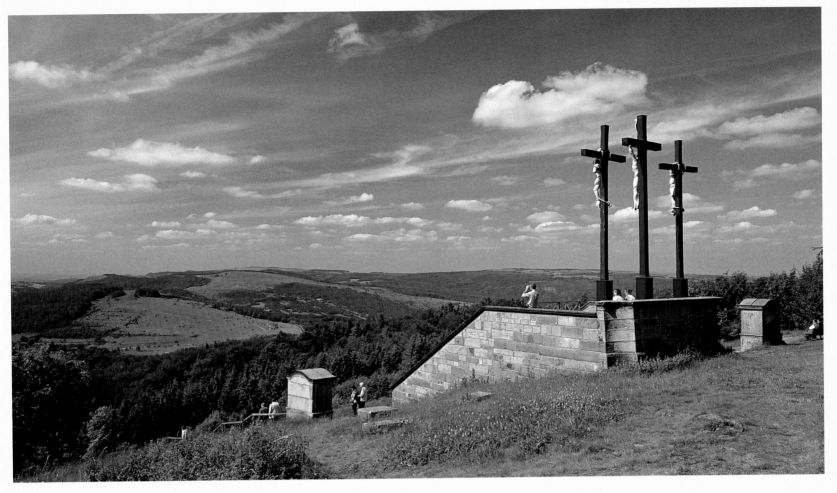

Tales of the forest

Where in the 1950s people still joked that in some pubs there was only one plate which had to be shared by both the host and his guests, today the Bayerischer Wald or Bavarian Forest need no longer fear comparison. On the contrary: in our modern day and age the relatively unspoilt scenery and down-to-earth qualities of the local populace are prized and much sought after assets. For centuries Central Europe's oldest and largest area of forest was considered impenetrable, a place where the local inhabitants kept themselves to themselves. The forest not only 'imprisoned' them, however; it also fed and protected them. It provided them with building materials for their houses and helped them to extract ore and later make the glass which was to earn the region such fame. Even in death it stood by them, inviting the dearly departed to rest on planks cut from its trees and take leave of it as if from an old friend. After burial these boards were stood up outside the chapel or nailed to a house or tree, returning the bier to its place of origin – and with them the people who were carried on them over the threshold of death.

Lakes ancient and modern

The moraine landscape north of the Alps is the product of Ice Age glaciers, with countless lakes dotted about the woods and meadows. The lakes of Starnberger See, Ammersee, Staffelsee and Chiemsee are in the foothills, with the Schliersee, Tegernsee and Königssee huddled at the foot of the Alps. The Starnberger See is not only the largest of them all and also part of the Starnberger Fünf-Seen-Land – together with the Ammersee, Wörthsee, Pilsensee and Weßlinger See – but has also been Munich's number one lido for many years. Before its shores were thrown open to the public this was where the Bavarian court came out to play. The first fleet to take to the water here belonged to Duke Albrecht V; the largest was owned by Elector Ferdinand Maria and his wife Adelheid of Savoy. In an attempt to emulate the hotly desired allures of the south in the Bavarian heartlands they turned the Starnberger See into a baroque showpiece, the main attraction of which was a huge ship modelled on the splendid galleys of the Venetian doges, powered by 110 rowers and accompanied by an entire fleet of gondolas and little boats. The lake accommodated up to 2,000 revellers on the largest of these occasions. Our contemporary use has since trumped this superlative; the royal pair would rub their eyes in disbelief at the hoards of holidaymakers now thronging the shores of Upper Bavaria's waterholes.

The man-made counterpart to the region's natural lakes was begun in the 1980s when the Danube and Altmühl rivers were dammed to form the lakes of Rothsee, Altmühlsee, Igelsbachsee and Kleiner and Großer Brombachsee. The Neues Fränkisches Seenland in the north of Bavaria owes its existence to the chronic water shortage north of the Danube. These reservoirs also have their own appeal, however, and have proved a popular holiday resort.

The Rhön is a veritable paradise for hikers, glider pilots – and pilgrims. The latter often head for the Kreuzberg where legend has it that St Kilian erected the first crucifix over 1,300 years ago, giving the hill its name (Kreuzberg = "mountain with the cross").

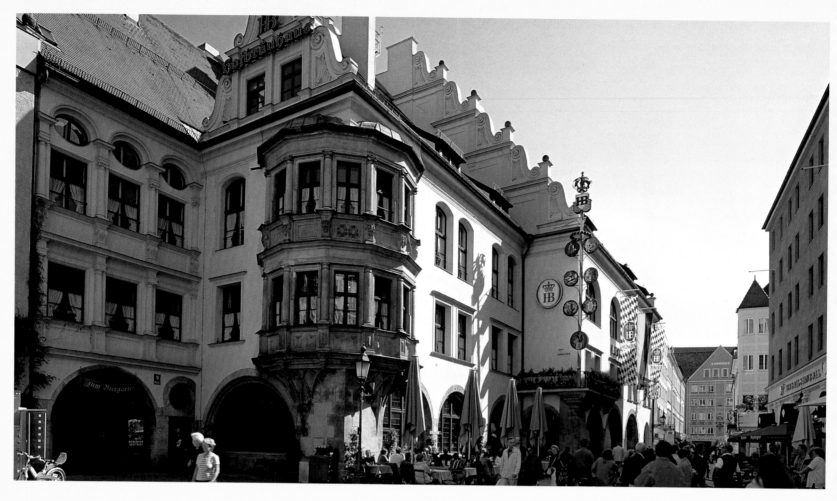

Right page:
The biggest public festival in the world is also held in Munich each September. Food and drink are served in enormous beer tents with all the mod cons, ensuring that hours of fun can be had at the fair (or Oktoberfest) whatever the weather.

Page 18/19:
The municipality of Lenggries comprises 50 villages and suburbs and covers an area of almost 250 square kilometres (96 square miles). The nearest mountain to the popular spa and ski resort is Brauneck.

Culinary delights

Even in Bavaria man does not live on beer alone! Local menus reflect both farming traditions and the idiosyncrasies of the indigenous population. One of these is the long white radish or *Radi* which no self-respecting cold platter of bread, cheese and sausage (*Brotzeit*) must be without. Although its hot taste may have limited its popularity to the confines of Bavaria, the more palatable, fellow Bavarian *Leberkäse* (meat loaf) is famous the world over.

The most Bavarian of all local sausages (and there are many) is without doubt *Weißwurst* or white sausage. The story goes that it was 'invented' on February 22, 1857, through the ingenuity of a young butcher's apprentice called Sepp Moser and the impatience of some hungry pubgoers who had ordered *Bratwurst* or fried sausage. The cook had run out of fine sausage skins and was forced to use a thicker substitute to encase the filling. He was also too lazy to fry the sausage and served it boiled – straight out of the pot. Instead of losing favour with his clientele Moser was praised to the skies and heralded as the creator of a new culinary delicacy.

Bavarians are also great cheesemakers, with the lush green pastures of the Allgäu the chief site of manufacture. Nowhere else in Germany is as much cheese produced as here, where you can choose from over 400 types of cheese and over double the amount of different flavours.

The domain of Bacchus

According to Goethe in his play *Götz von Berlichingen* Franconia was "a land blessed". Nuremberg in particular was one of his best loved locations – with the one disadvantage that it didn't grow wine. Goethe's favourite tipple was Würzburger Stein. He was in good company; as far back as the 12th century abbess Hildegard von Bingen had praised Würzburg's local vintages to the skies. Her arguing that it had more healing properties than any other wine is still used as a good excuse for a party today. In c. 1650, of the three most famous wine-growing areas in Germany two were in Franconia:

Zu Klingenberg am Main,	*In Klingenberg on the Main*
zu Bacharach am Rhein,	*In Bacharach on the Rhine*
und zu Würzburg auf dem Stein,	*And in Würzburg on the Stein*
da wächst der beste Wein.	*There grows the finest wine.*

It wasn't just the quality but also the quantity of the beverage which for many years set standards in the wine-growing industry – when the area of cultivation was seven times the size it is now. It covered ca. 40,000 hectares (almost 100,000 acres) and stretched as far as the Upper Main Valley. God Bacchus didn't reside in Rheinhessen or the Palatinate; his domain was Franconia. And although there may not be as much of it around today as there was then, among connoisseurs wine from Franconia is considered to be something very special.

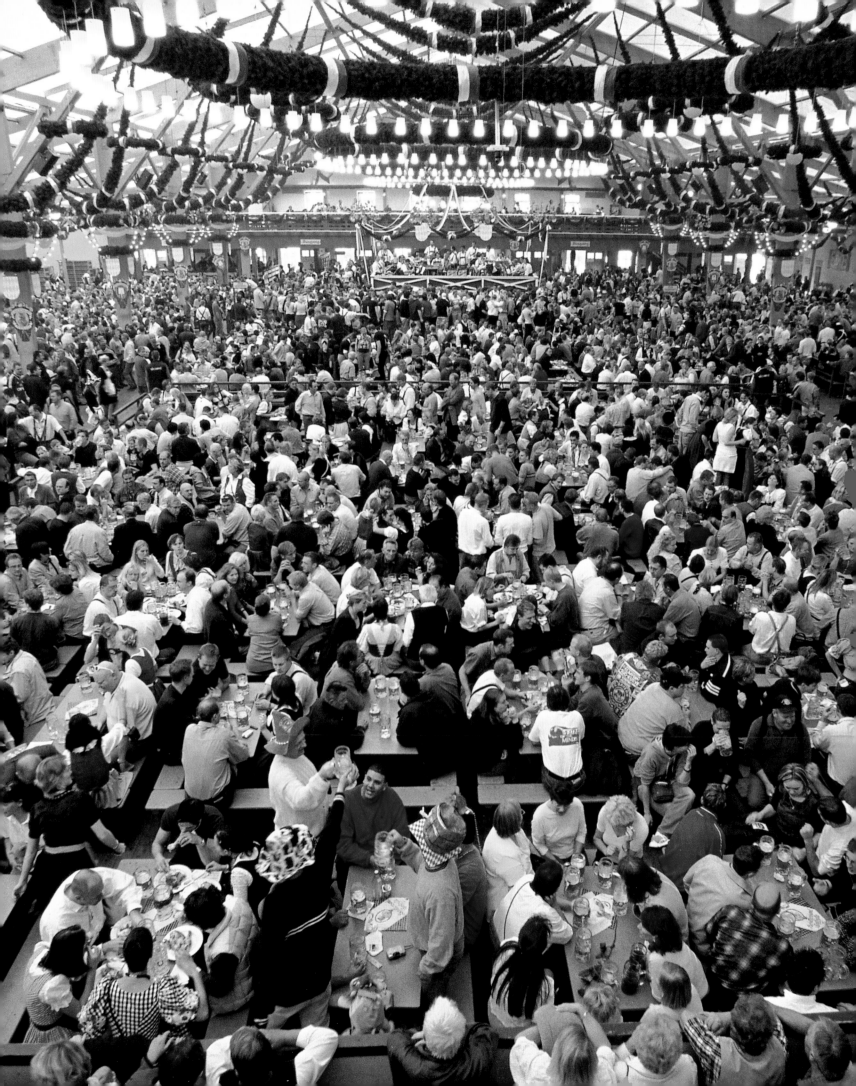

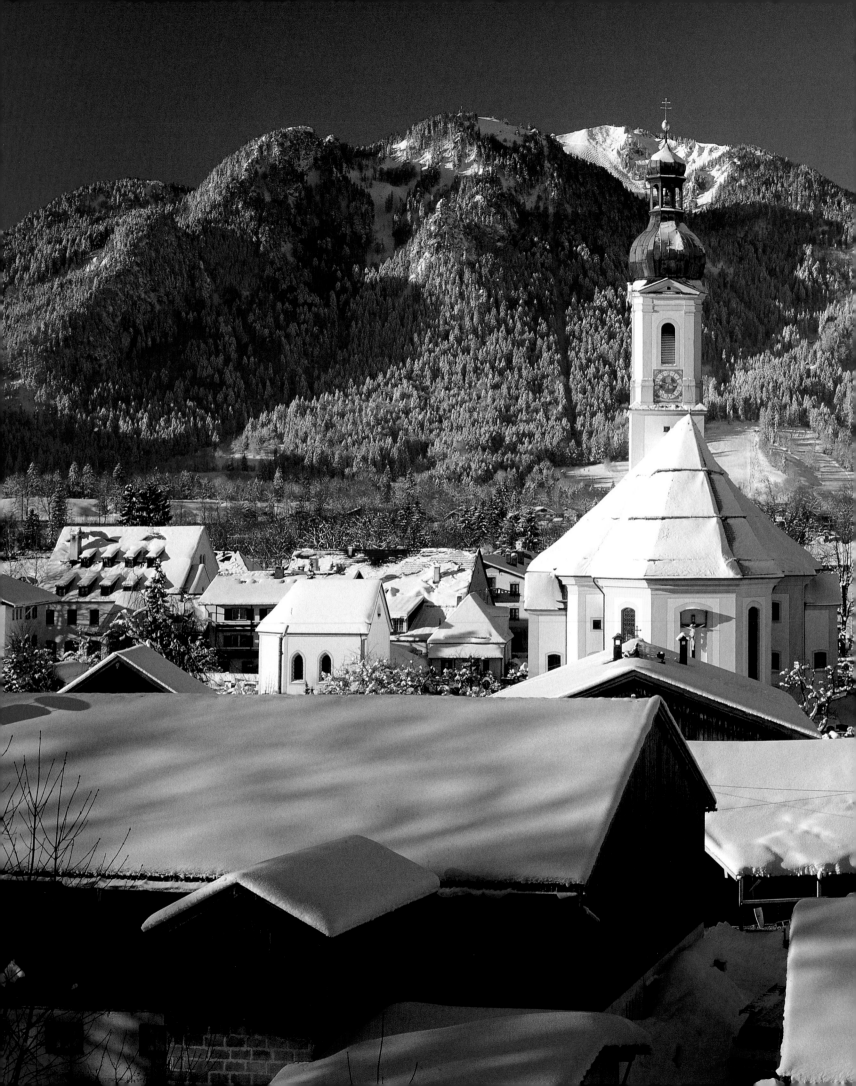

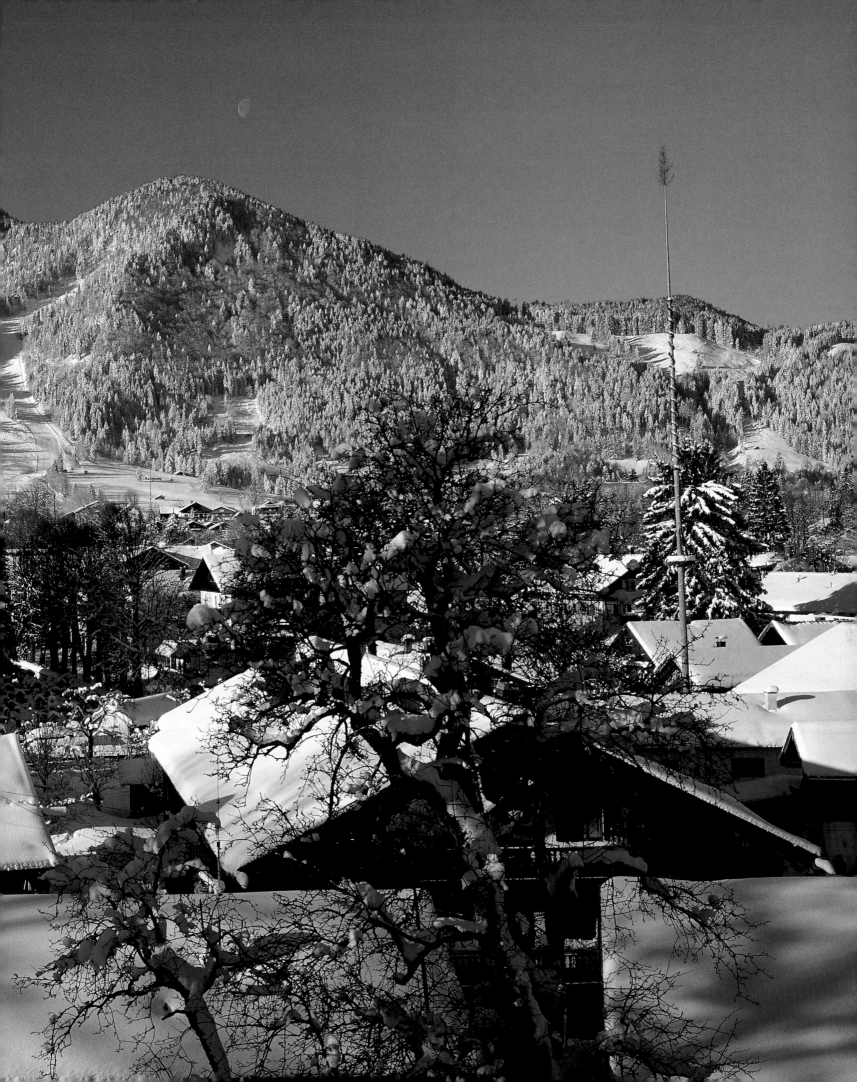

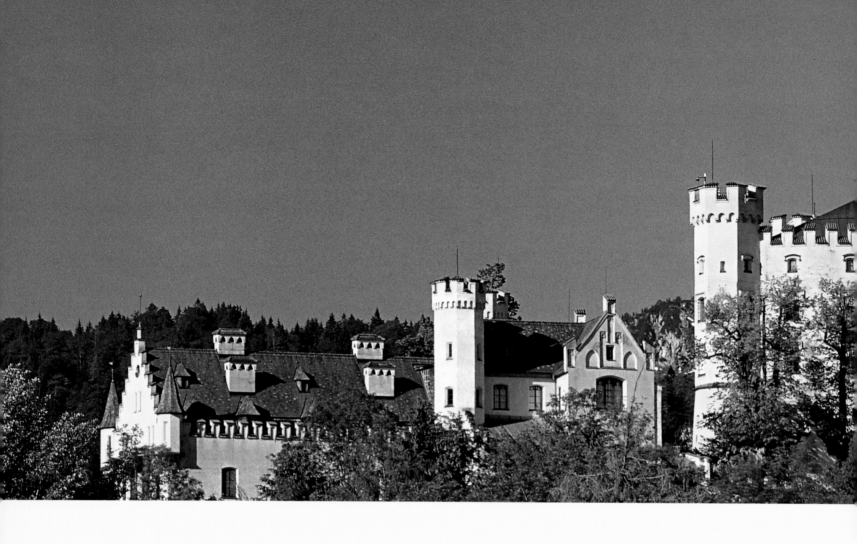

FROM UPPER BAVARIA TO SWABIA – THE SOUTH

Bordered by the Alps in the south, the Altmühl River in the north, the Salzach in the east and the Lech in the west, Upper Bavaria, the largest administrative district in the free state, sprawls across about a quarter of Bavaria. Almost four million inhabit its ca. 17,500 square kilometres (ca. 6,750 square miles). They are joined each year by thousands of visitors who come to admire the many spectacles and seasonal nuances of the natural surroundings and enjoy the practical sense and warm hospitality of the local populace. This is a place of character and originality – with people to match.

The most powerful players, however, are the Alps whose Ice Age glaciers once forged their way deep into what is now the Alpine foreland. Among their spectacular legacies are the many lakes of Upper Bavaria, with five of them – Ammersee, Wörthsee, Pilsensee, Weßlinger and Starnberger See – forming a veritable Bavarian lake district. The latter, the nearest to the state capital, has been nicknamed the "bathtub of Munich" – for good reason.

The Swabian bit of Bavaria (Bayerisch Schwaben) has only been part of the free state since the beginning of the 19th century. It starts in the north with the Ries, a huge crater pounded into the earth by a giant meteor, continues along the valley of the Upper Danube, reaches its much visited, urban climax at Augsburg and finally aspires to celestial heights in the rolling pastures and giddy peaks of the Allgäu.

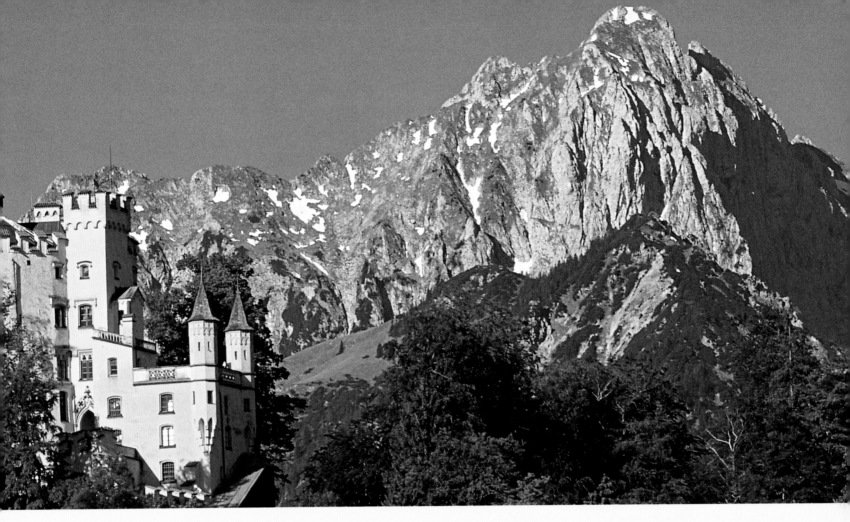

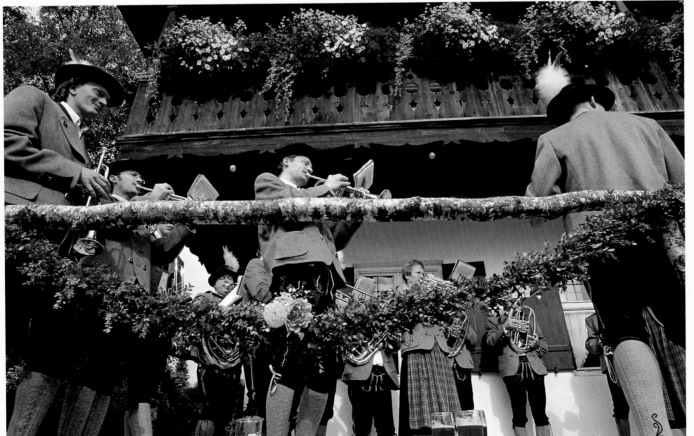

Above:
In the 12th century Burg Schwanstein was where minnesinger Hiltpolt and his knightly colleagues serenaded their lady loves. The present castle of Hohenschwangau was erected during the first half of the 19th century. The neo-Gothic edifice was planned by theatrical artist Domenico Quaglio and built by Josef Ohlmüller.

Left:
Tutzing is the second-largest town on the Starnberger See. Two of the biggest tourist magnets are the yearly Fischerstechen festival and the historic Fischerhochzeit or fisherman's wedding, shown here.

21

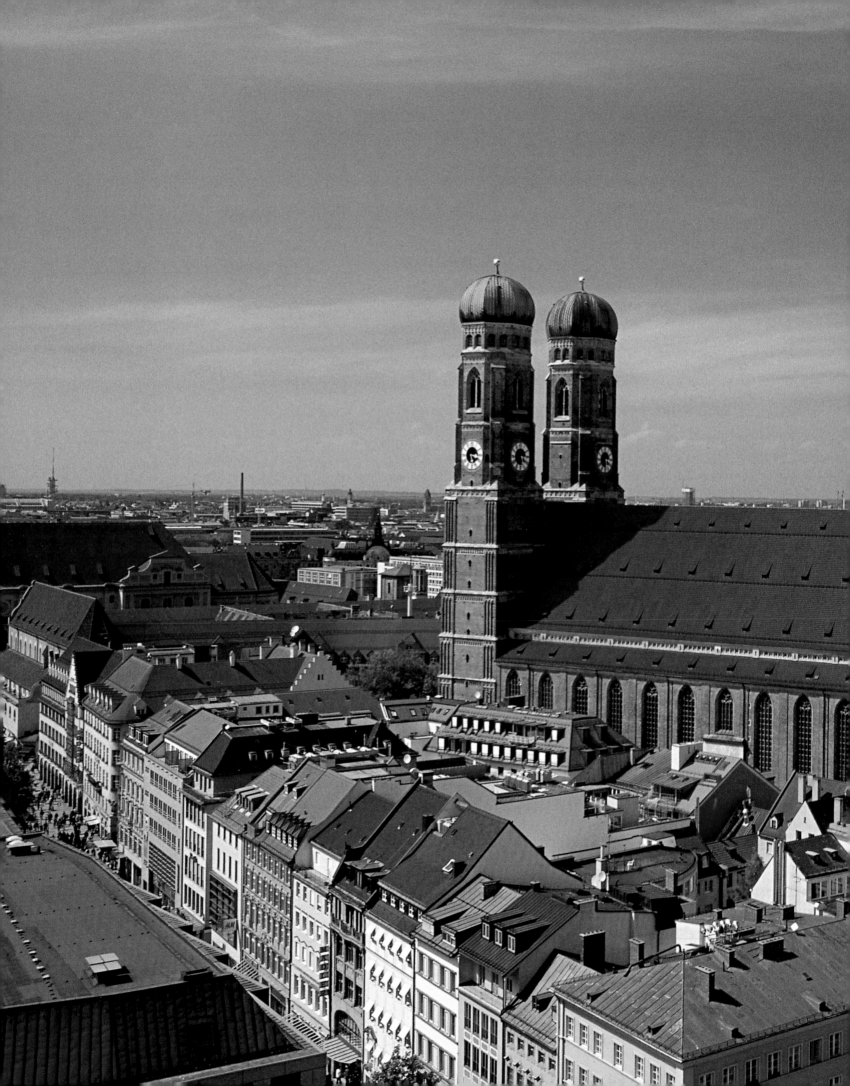

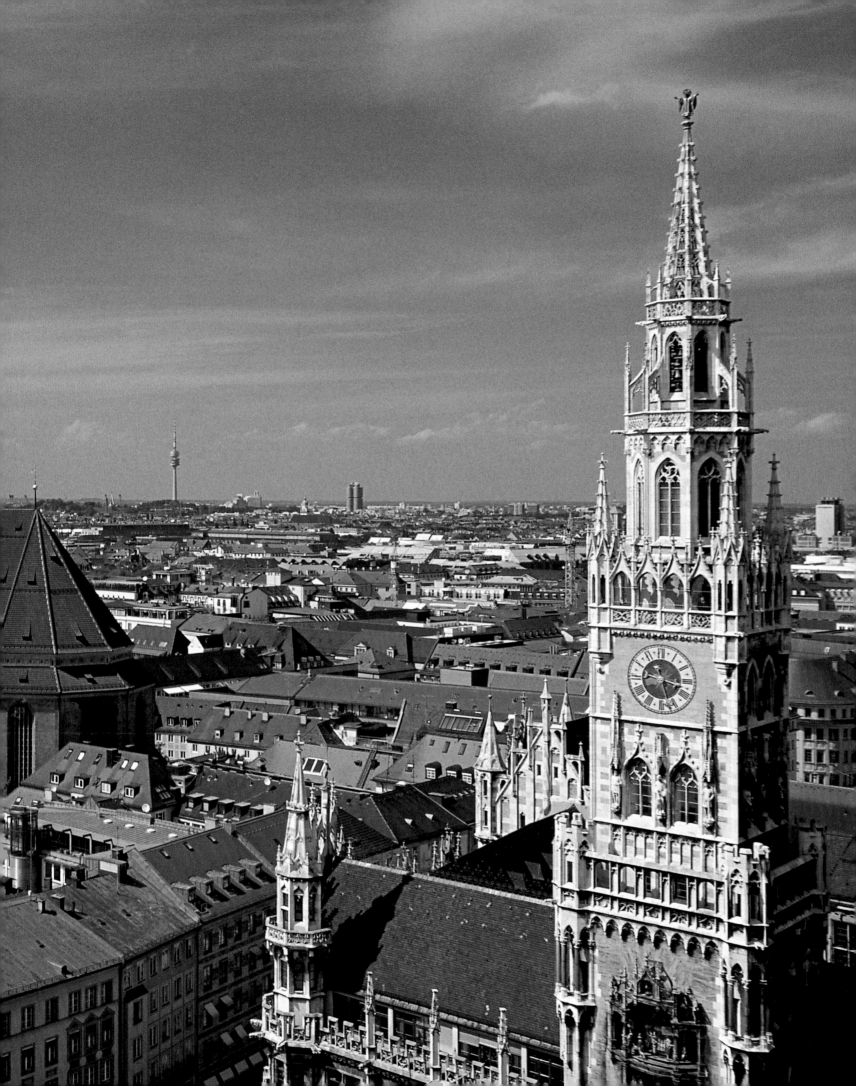

Page 22/23:
No pain, no gain: to get to the top of the steeple of St Peter there are exactly 302 steps to climb. It's worth the effort, however; Munich's oldest parish church has fantastic views of Marienplatz, the Frauenkirche and Neues Rathaus.

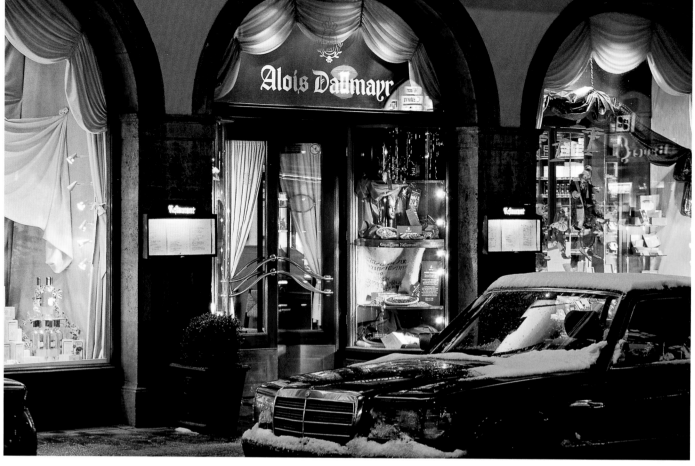

What started out as a grocer's store 300 years ago has since become Dallmayr, a coffee importer's and delicatessen of renown on Munich's Dienerstraße. Even outside you can smell the freshly ground coffee, stored in magnificent porcelain jars made in Nymphenburg.

View of the Schwemme or public bar of the Hofbräuhaus – which seats a staggering 1,300! The city's number one "watering place" (Schwemme) was originally in the Alter Hof or old palace and reserved for the exclusive use of Munich's top brass. It was later moved to its present site on Platzl and opened to the public at large.

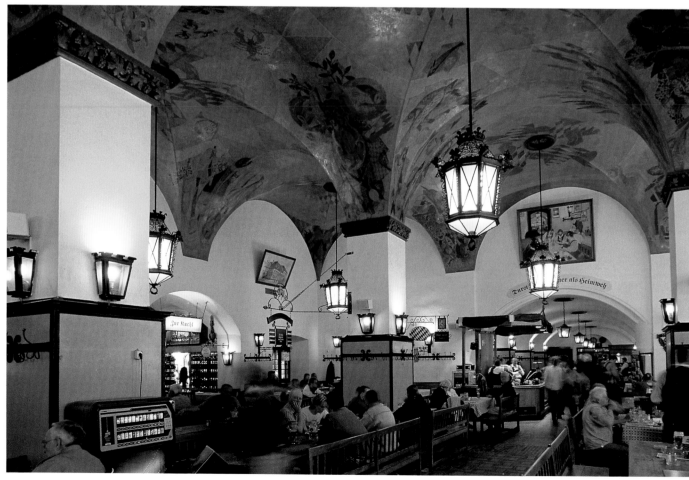

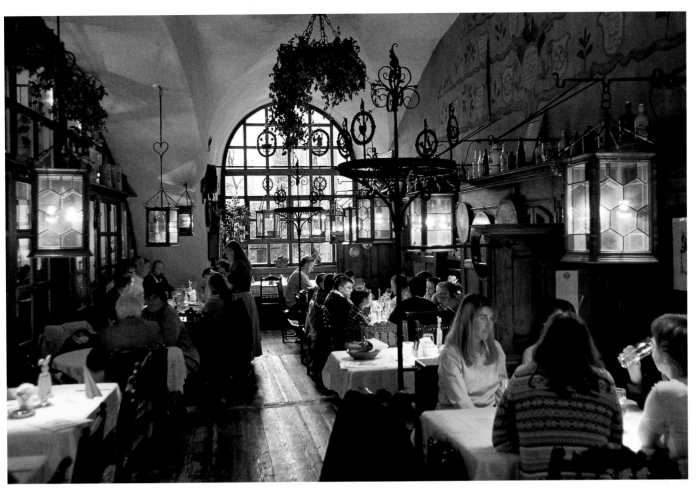

Although many of Munich's microbreweries have lost their independence and are now owned by a handful of large concerns, the Bavarian metropolis is still the regional capital of beer. The photo shows the traditional Hackerhaus on Sendlinger Straße.

Munich's Residenzstraße by night, named after the royal residence of Munich's dukes and later electors and kings which is situated on the northeastern edge of the old town. The palace is now used as a museum which includes the well-known Cuvilliés-Theater and Festsaalbau, formerly the throne room.

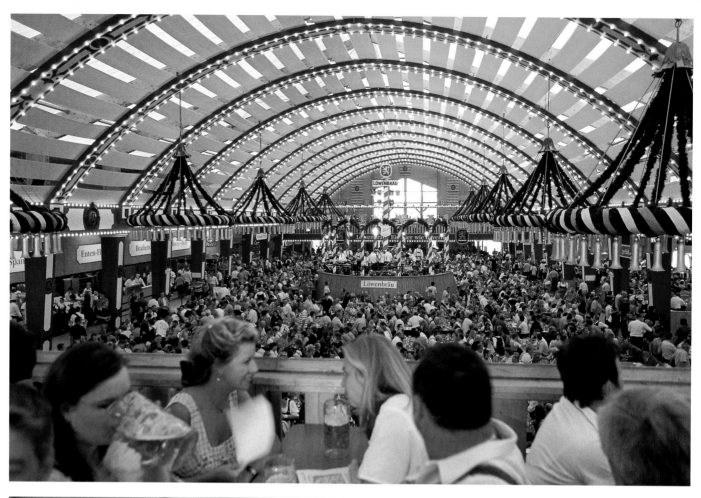

The Löwenbräu beer tent at the Munich Oktoberfest. Its exuberant size – and that of the others – is born of necessity to accommodate the hundreds of visitors who flock here during the festival. It's still not easy to get a seat, especially if you come in the evening.

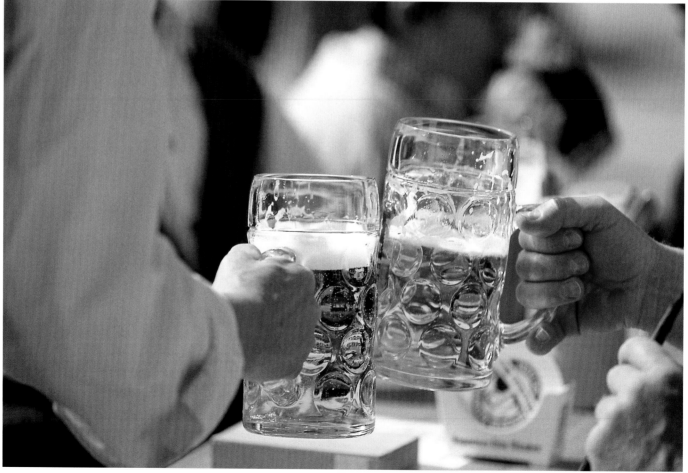

Centred around the church of Mariahilf in a suburb of Munich, the Auer Dult festival and funfair on the last Sunday in May lasts a long nine days. Beer is naturally one of the chief means of sustenance, served in huge litre Maß glasses which are lustily clinked before being emptied.

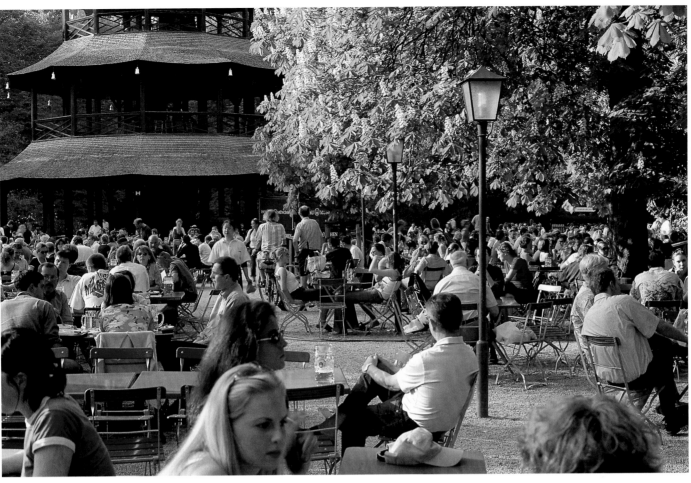

Landscaped gardens and beer gardens are usually two separate entities. Not in Munich. Germany's largest city park, laid out between 1789 and 1837 and largely attributed to Ludwig von Sckell, also boasts one of Munich's most popular outdoor pubs at the Chinese pagoda.

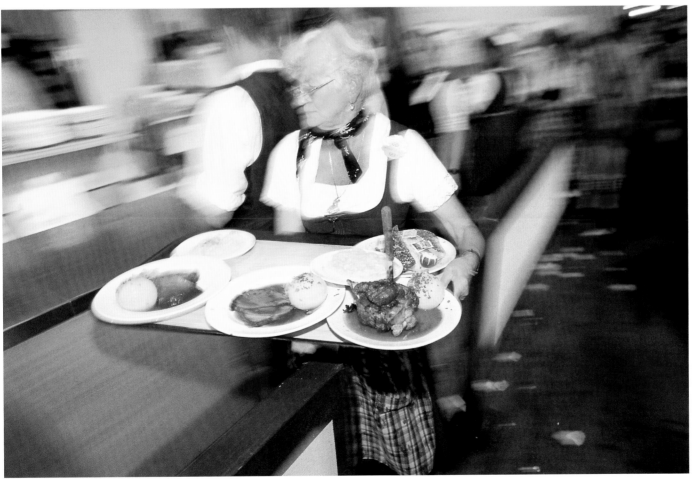

Munich's Oktoberfest wouldn't be the same without its chic – and resolute – waitresses. For hours at a time they scurry back and forth between the tables and the bar, armed with up to ten litre glasses of beer – a job which is not for the faint-hearted.

For centuries the River Isar lived up to its name of "the raging" until the 1950s, when it was tamed by the construction of the Sylvenstein dam. Since then both its character and freight have changed, with tourists on river barges now the main cargo as opposed to the wood, lime and gypsum of old.

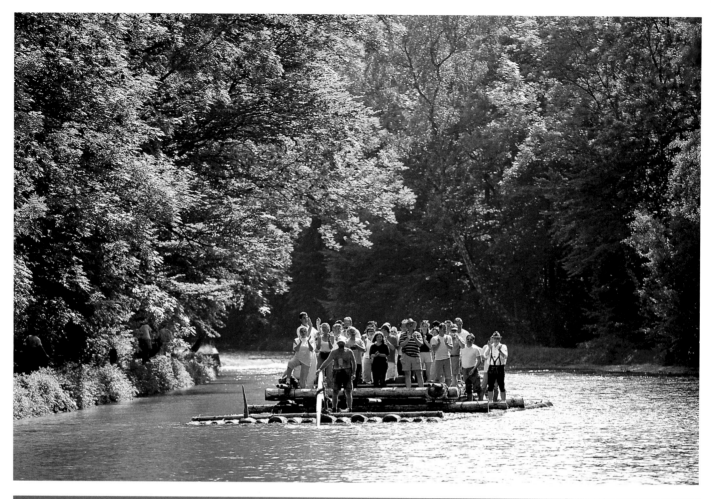

Karlsplatz is named after Bavarian elector Karl Theodor who in 1791 had the city's 14th-century defences torn down. Munich's popular meeting place is nevertheless usually referred to as Stachus. The squat Karlstor in the background took on its present appearance during the 19th century.

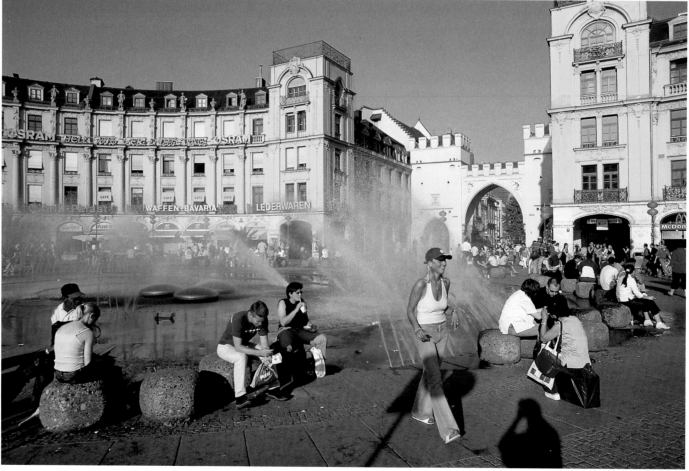

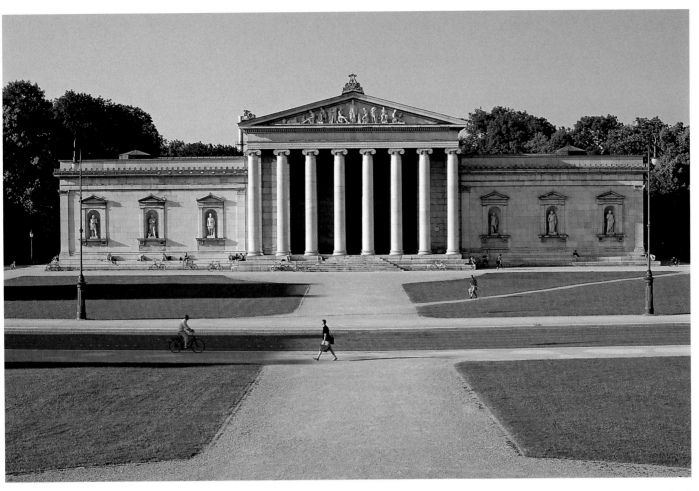

The Glyptothek on
Königsplatz is one of the
most famous neoclassical
buildings in Germany and
marks Leo von Klenze's
debut in Munich. It was
also the first German
museum to be opened to
the public.

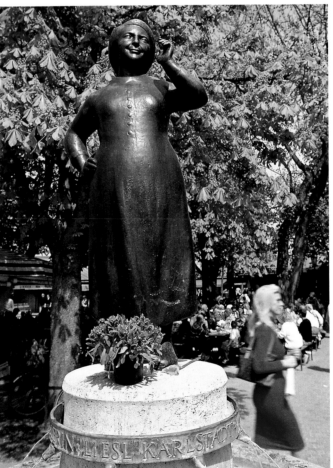

Left and far left:
The Viktualienmarkt in
Munich is the place to
meet Germany's famous
folk actor and cabaret
artist Karl Valentin and his
equally eccentric colleague
Liesl Karlstadt, both of
whom have a statue here.

Page 30/31:
Huddled at the foot of the
Kleiner Watzmann the
peninsular of St Bartho-
lomä juts out into the
clear green waters of the
Königssee. Originally
12th century, the baroque
pilgrimage chapel of the
same name is dedicated to
the Holy Trinity and the
Virgin Mary.

29

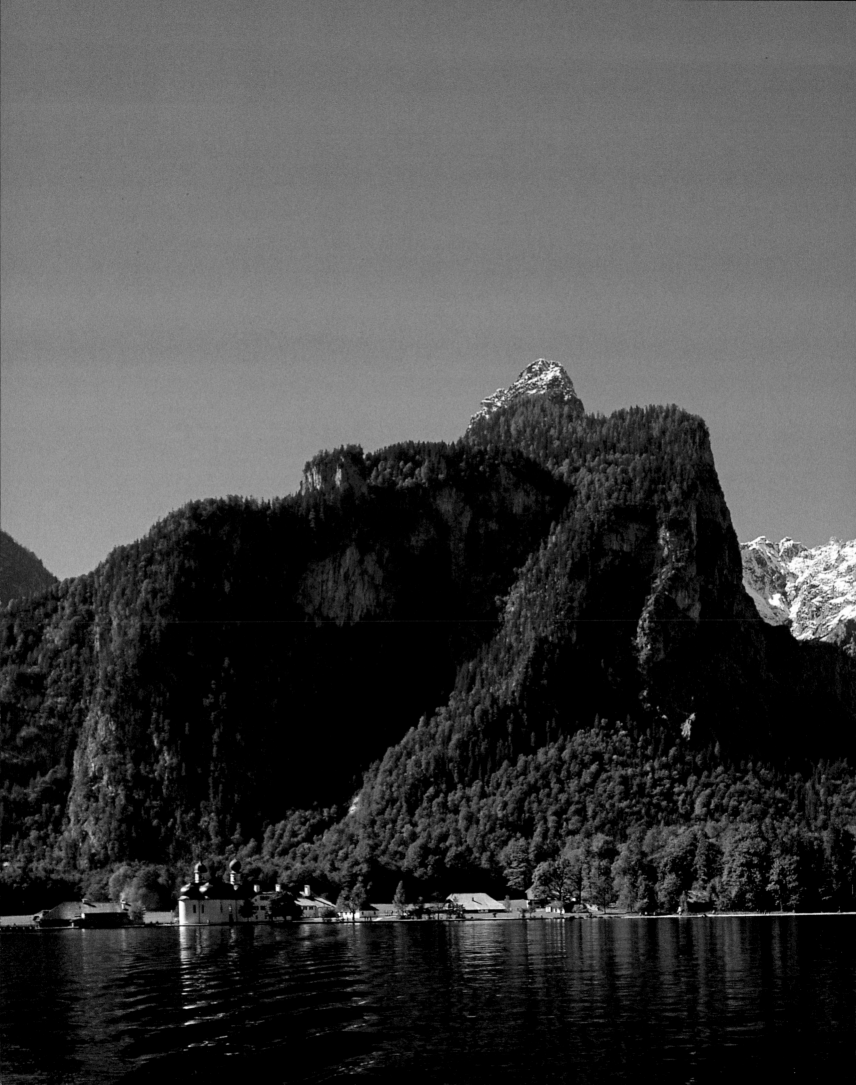

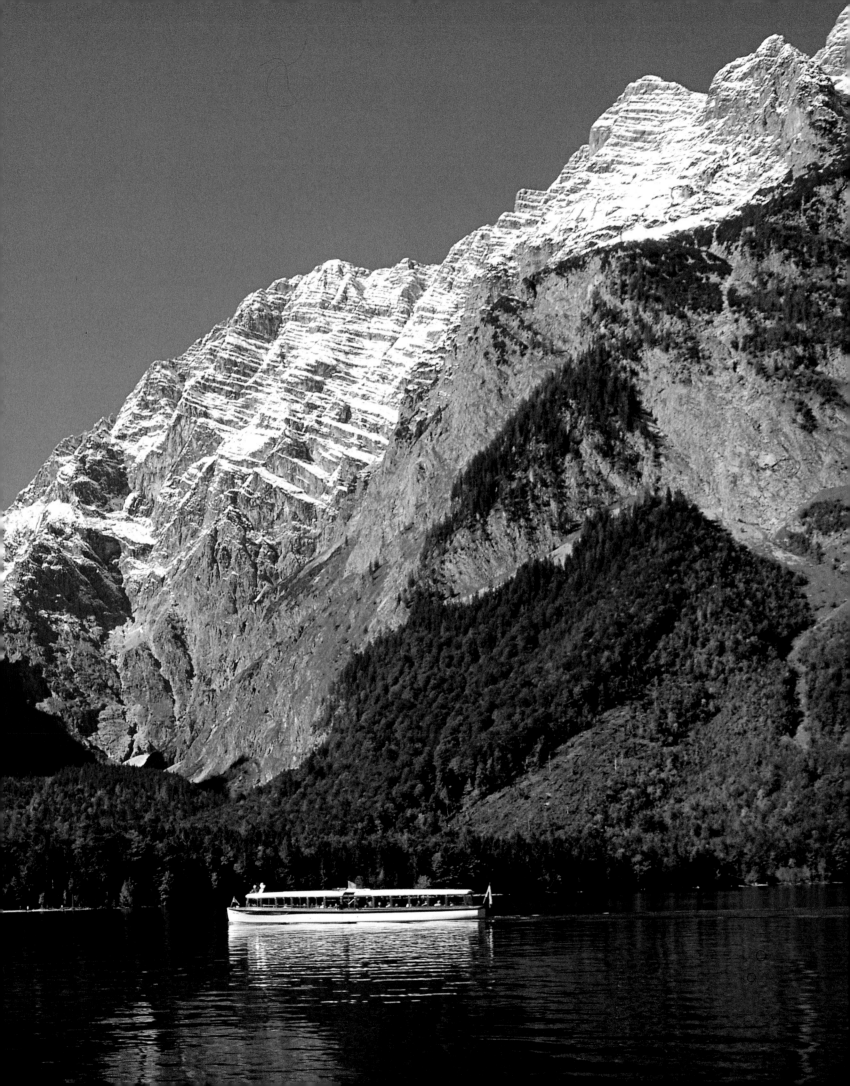

The first monastery on
the "holy mountain" of
Andechs dates back to the
mighty dynasty of Dießen-
Andechs and Meranien.
Following their extinction
in the 13th century the
Wittelsbachs founded the
present Benedictine abbey
here in 1455. Its centre-
piece is the late Gothic
pilgrimage church, later
refurbished in the style of
the Rococo.

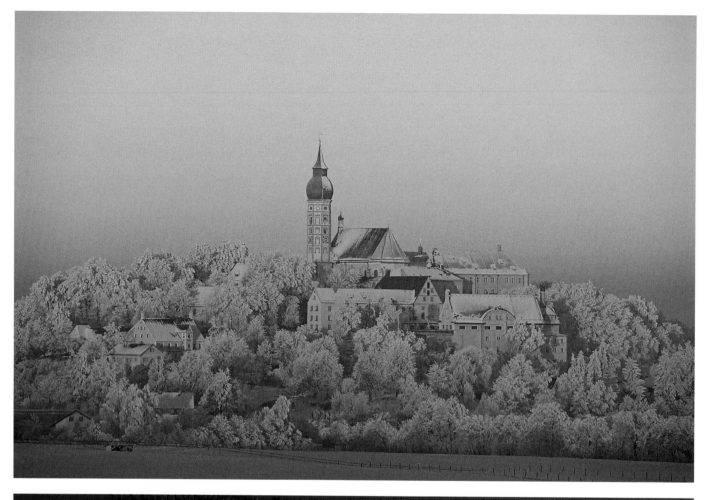

Dedicated to St John the
Baptist and St George,
from the church in
Holzhausen you not only
have grand views of the
Starnberger See; with its
octagonal tower and onion
dome the church itself is an
eye catcher, particularly in
the Christmas snow.

Marktstraße in Bad Tölz, its facades lavishly adorned with frescoes and stucco, provides the perfect setting for the town's Christmas market. The buildings date from the 15th to 18th centuries and were adapted to create a harmonious whole by Gabriel von Seidl at the beginning of the 20th century.

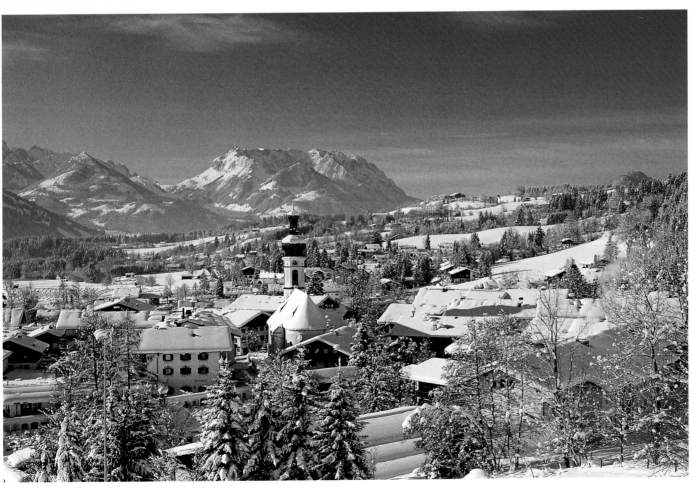

Almost 700 metres (2,300 feet) above sea level, Reit im Winkl is not only home to ski idol Rosi Mittermaier but also one of the most famous winter resorts in Germany. Discovered in the mid 19th century by King Maximilian II, the area has plenty of snow each year.

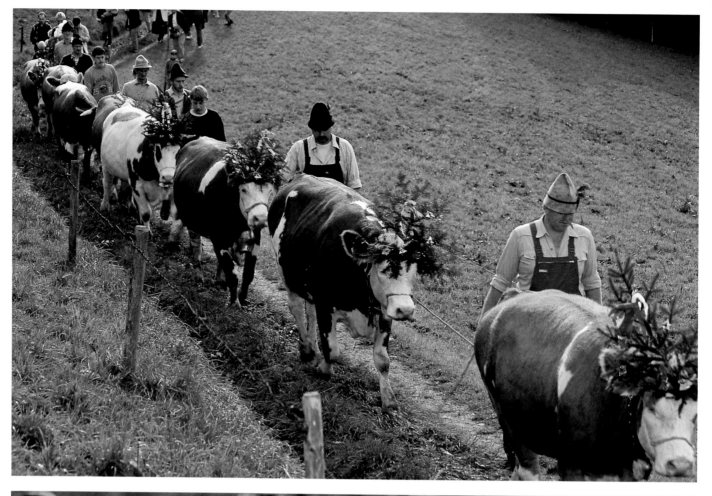

Driving the cattle down from the mountains in Stoißberg in the Chiemgau Alps. Even though most tourists now appreciate how hard things were for the Alpine dairymen, their way of life is still often associated with the promise of erotic pleasures in the haystack …

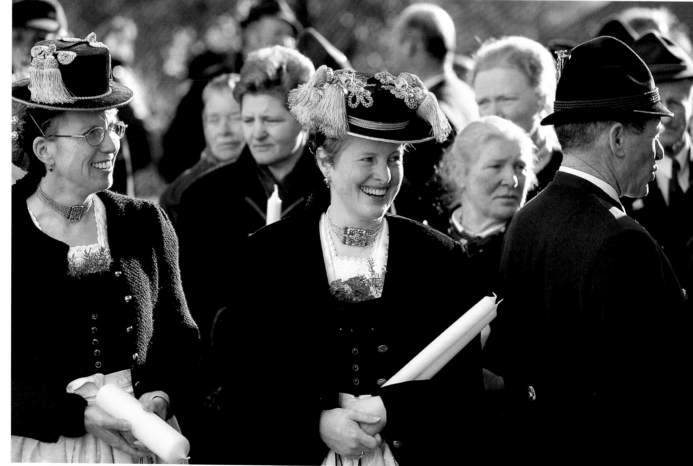

Dedicating candles on St Leonard's Day (November 6) in Greimharting. After being the patron saint of prisoners and the mentally infirm for many years, St Leonard then changed his vocation, with his main attribute – the chain – now being associated with animals and not people.

Right page:
For many the Berchtesgadener Land is the epitome of German Alpine romanticism. Made a national park in 1978, around each corner a new glorious panorama unfolds. The church of St Fabian and St Sebastian in Ramsau is without a doubt one of the most photographed motifs in this magnificent part of the country.

34

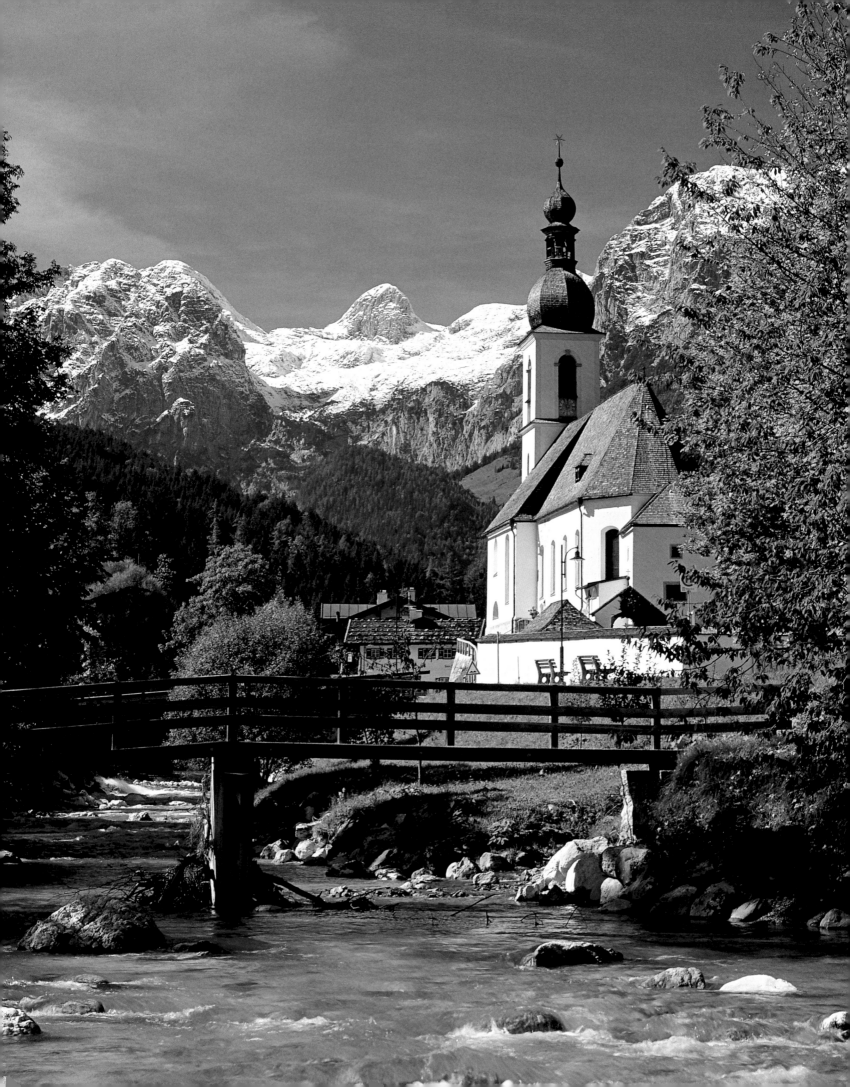

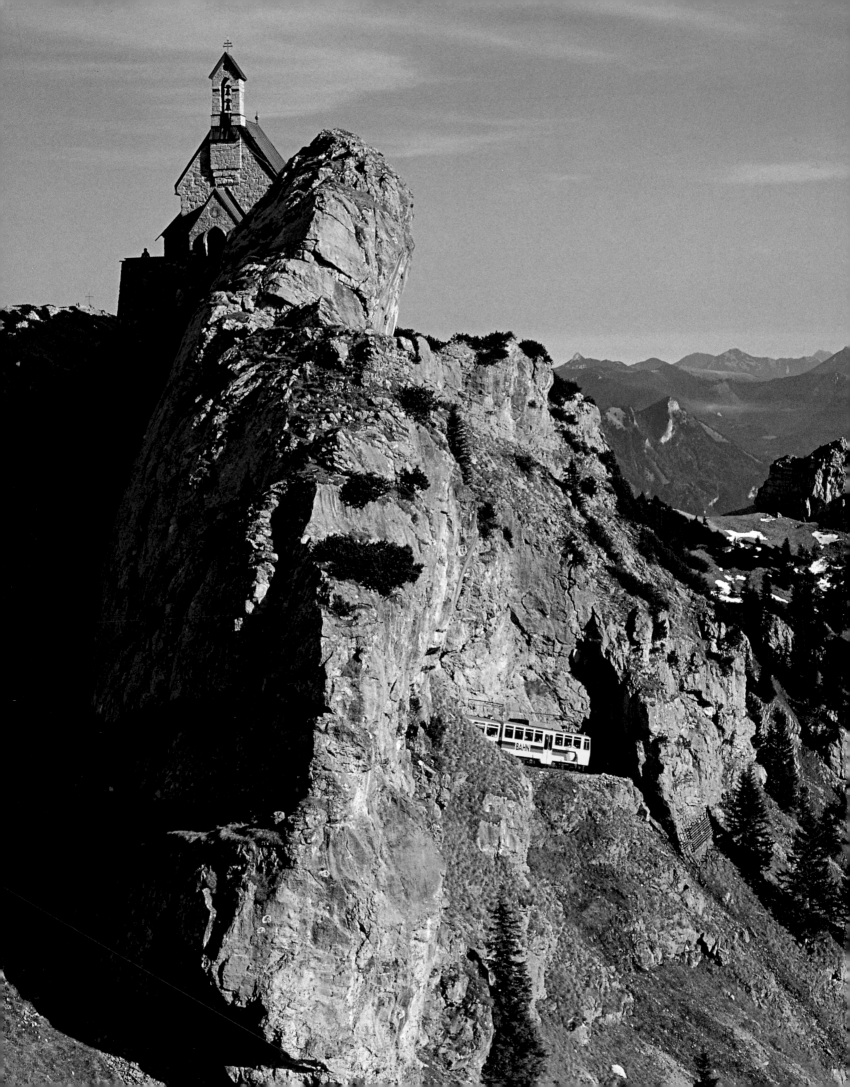

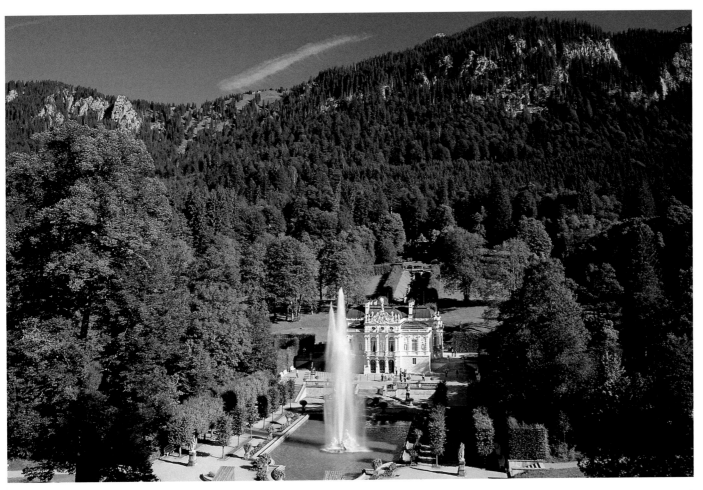

Left page:
Although 'only' 1,838 metres (6,030 feet) high, the Wendelstein puts all other mountains near it to shame. This classic viewpoint in the eastern Alps was made accessible to the public in 1912 when a rack railway, still in operation, was set up here.

Schloss Linderhof was conceived as the Versailles of Bavaria. During construction Ludwig II had a change of heart, however, and settled instead for a "kingly villa" which – compared to his other palaces – was on a much more modest and private scale. It was the only one of his royal residences to be completed during his lifetime.

After being crowned German emperor in Rome in 1328 – the first Wittelsbach to be so – Ludwig der Bayer paraded home to found Kloster Ettal. It was later dissolved during the secularisation of Bavaria, with the Benedictines only returning to the monastery around 100 years ago.

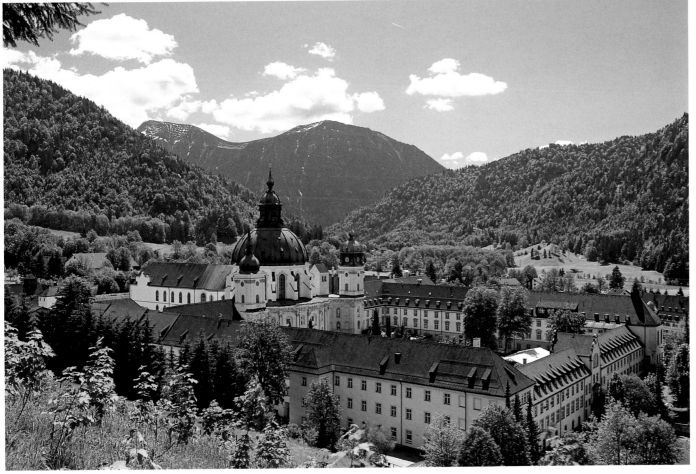

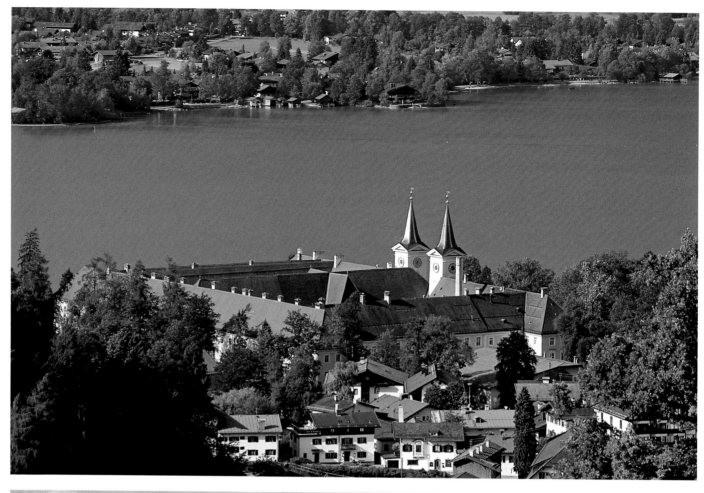

Founded in 746 by brothers Adalbert and Oatker from the dynasty of the Huosi, the Benedictine abbey of St Quirin on the Tegernsee grew into one of the most important monasteries in South Germany. At the heart of the complex is the church, refurbished in baroque by Munich's royal architect Enrico Zuccalli.

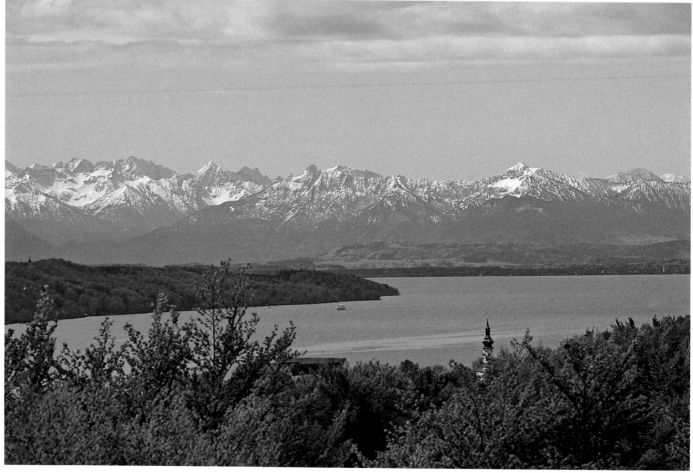

The Starnberger See, also known as the Würmsee after its single drain, the River Würm, is up to 127 metres (417 feet) deep and almost 60 square kilometres (23 square miles) in area. The only Bavarian lake which is bigger – yet only half as deep – is the Chiemsee at 80 square kilometres (30 square miles).

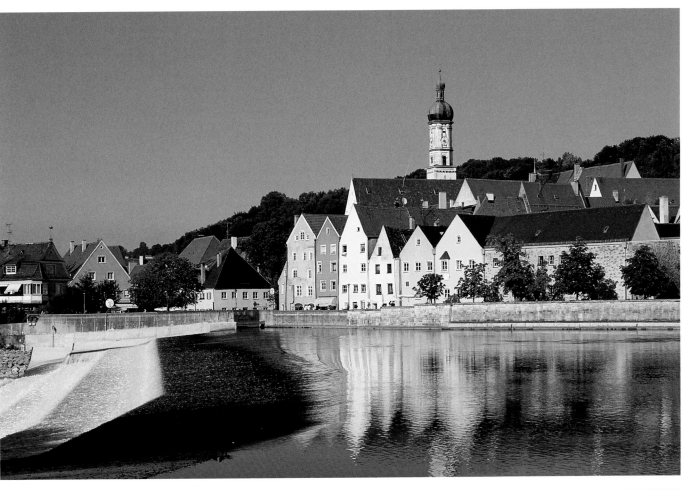

Landsberg on the River Lech is like something out of a picture book and very medieval in character. The largest of its churches is the parish church of Mariä Himmelfahrt, an aisled basilica from the 15th century which was baroqueified in c. 1700.

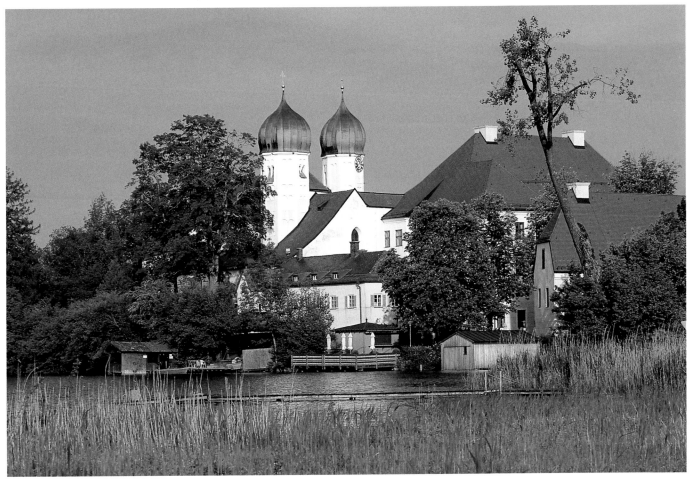

Since its 1,000th anniversary the Benedictine monastery of Seeon, tucked away on an island in the Klostersee, has regained much of its former glory. For centuries it was one of the cultural and artistic centres of the Chiemgau, with the church of St Lambert as it focal point. It now houses an educational institution.

39

Once a Germanic thing-stead, Altötting is now the most frequented place of pilgrimage in Germany. Its many buildings make up a pleasing ensemble: (from left to right) the baroque Jesuit church dedicated to St Magdalene, the chapel of mercy with its religious relic from c. 1300 and the old monastic church which is now used by the local parish.

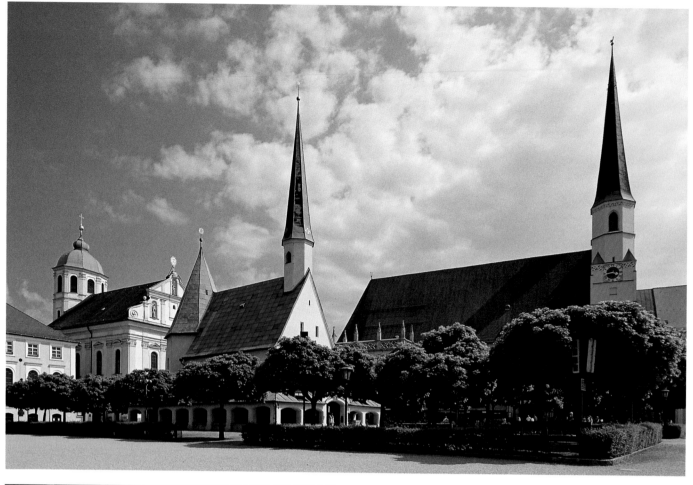

The old brewing room at the Schlossbrauerei zu Au in the Hallertau has been lavishly restored and now provides a original setting in which to enjoy some regional cuisine and – of course – a glass of the local brew.

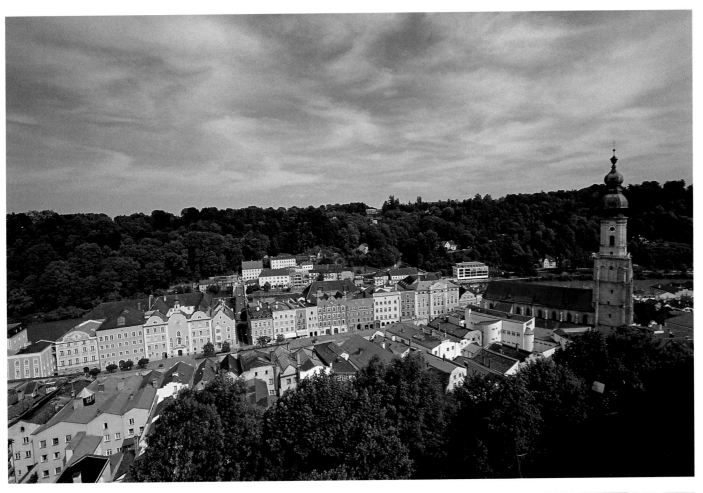

Burghausen certainly lives up to its name of "fortified house". Europe's longest castle has one central defensive structure plus three dozen other buildings and towers. From the fortress there are good views of the old town clinging to the banks of the River Salzach, for a time the second residence of Lower Bavaria's mighty dukes.

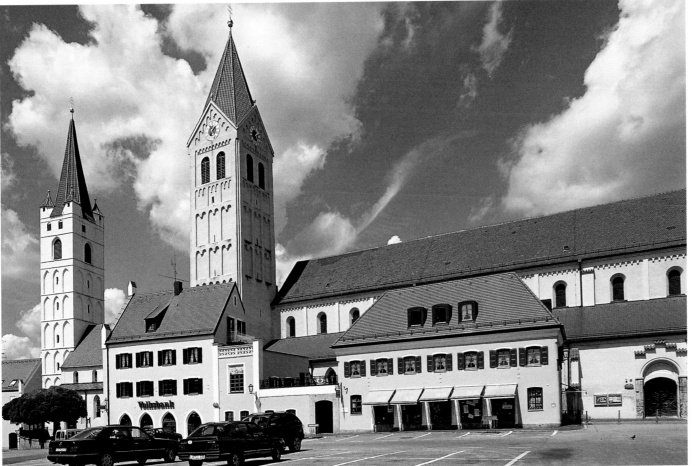

The greatest legacy of the former Benedictine monastery and collegiate church in Moosburg on the Isar is the present parish church of St Castulus. The aisled basilica dates back to the second half of the 12th century and is noted for its glorious Romanesque portal.

Page 42/43:
From the Marienbrücke which bridges the precipitous lunge of the Pöllat Gorge there are the best views of Schloss Neuschwanstein to be had, particularly on a fine day such as this one.

41

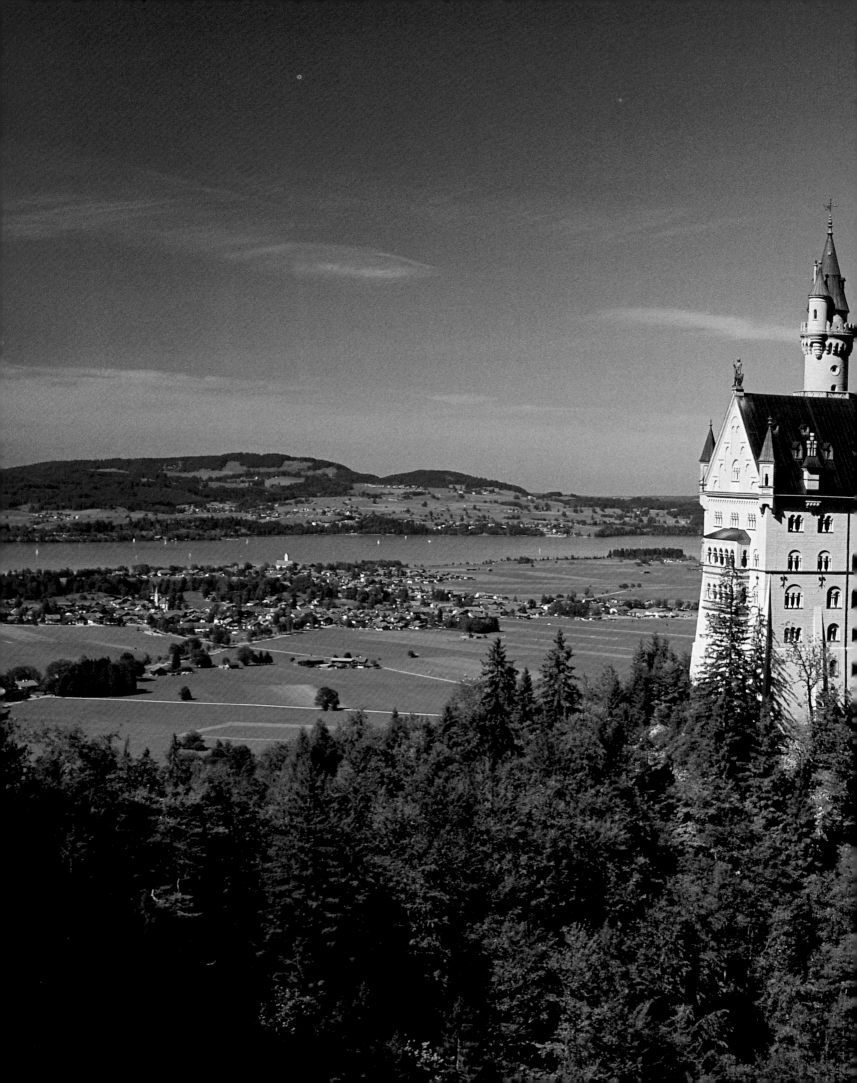

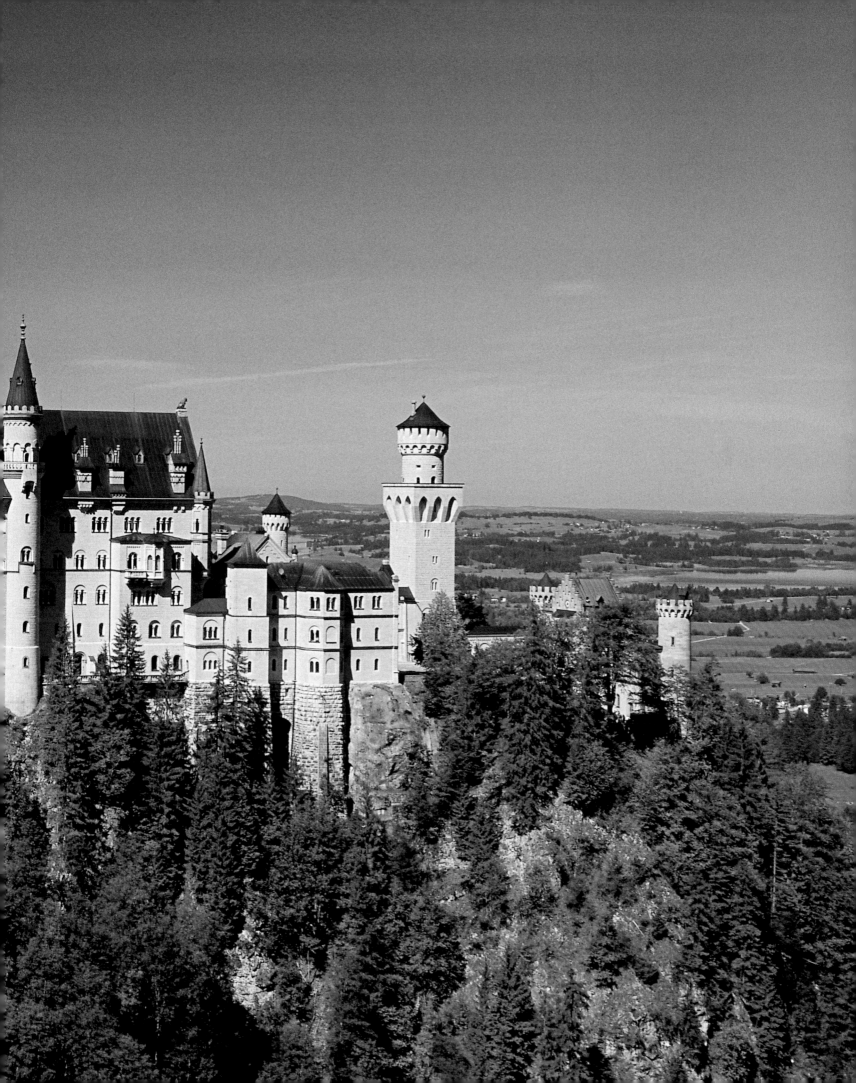

View of Schloss Neu-
schwanstein and the
Forggensee. The lake was
created about 50 years ago
when the River Lech was
dammed. 12 kilometres
(7.5 miles) long and up to
three kilometres (two miles)
wide, the lake is the fourth
largest in Bavaria.

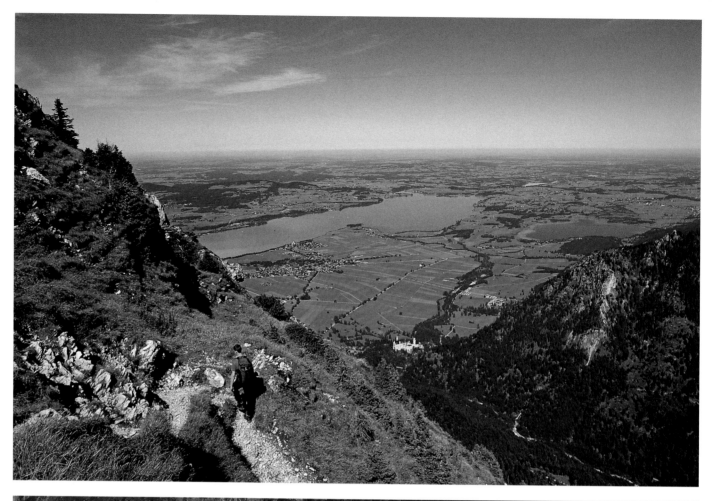

The forerunner of Hohen-
schwangau was Burg
Schwanstein, the ruins of
which were procured by
Crown Prince Maximilian,
later King Max II, and
turned into a summer
residence. The castle fur-
nishings date back to the
Biedermeier period.

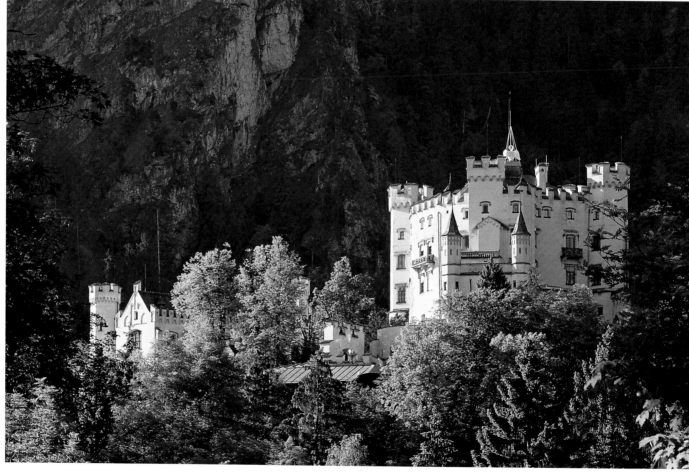

1,832 metres (6,010 feet) high, the Hochgrat is the highest mountain in the Nagelfluh Range. Its cable car is on hand to transport the less energetic to its summit where fantastic views out across Lake Constance and Säntis Mountain can be enjoyed.

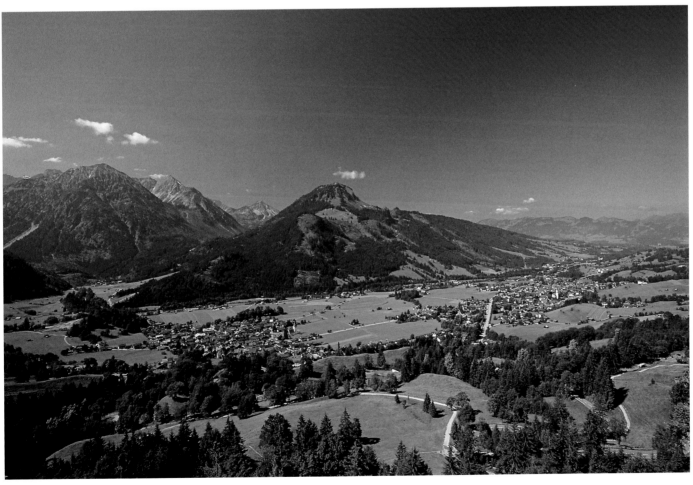

View of Bad Oberdorf and Bad Hindelang, four fifths of which are either country park or nature reserve. In the background on the right is the Imberger Horn whose distinctive peak (1,656 m / 5,433 ft) preludes the higher elevations beyond it.

In the Allgäu, the "land of happy cows", there are ca. 400 types of cheese and over double the amount of different flavours. It's thus hardly surprising that this – according to the locals – is where you can get the best Käsespätzle in Germany, an Allgäu variation on macaroni cheese.

The Allgäu museum of Alpine farming in Immenstadt-Diepolz also focuses heavily on cheese, much of which is now made industrially. At the museum dairy visitors can find out how it used to be made by hand in a process requiring skill and lots of patience.

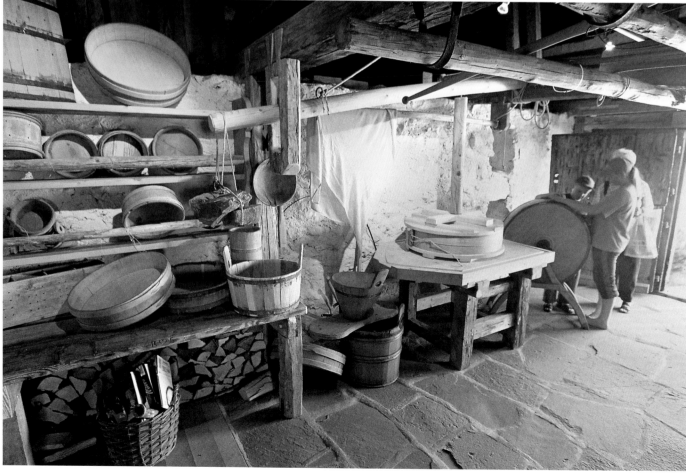

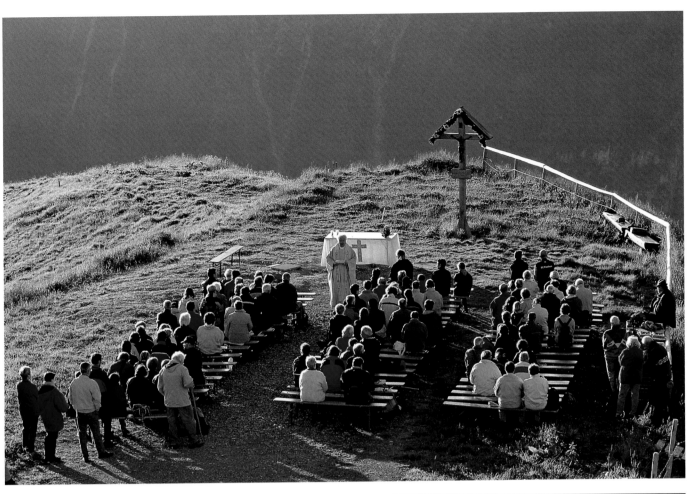

It's the early bird that catches the worm; here early risers catch the first rays of sunshine at a mass being celebrated on top of Fellhorn Mountain in the Allgäu.

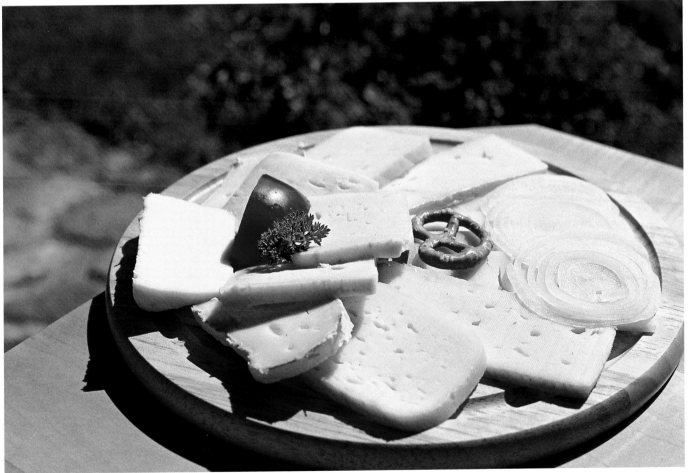

Whether you're vegetarian or not, this cheese platter is probably enough to set most mouths watering. Swiss farmer Johann Althaus first introduced the art of cheesemaking to the region in 1827, teaching locals how to turn creamy cow's milk into delicious Emmental-type cheese.

Page 48/49:
St Georg in Nördlingen is one of the largest medieval hall churches in Germany. From the top of its steeple – known locally as Daniel – there's a good bird's-eye of the town which is situated on the Romantische Straße or Romantic Route.

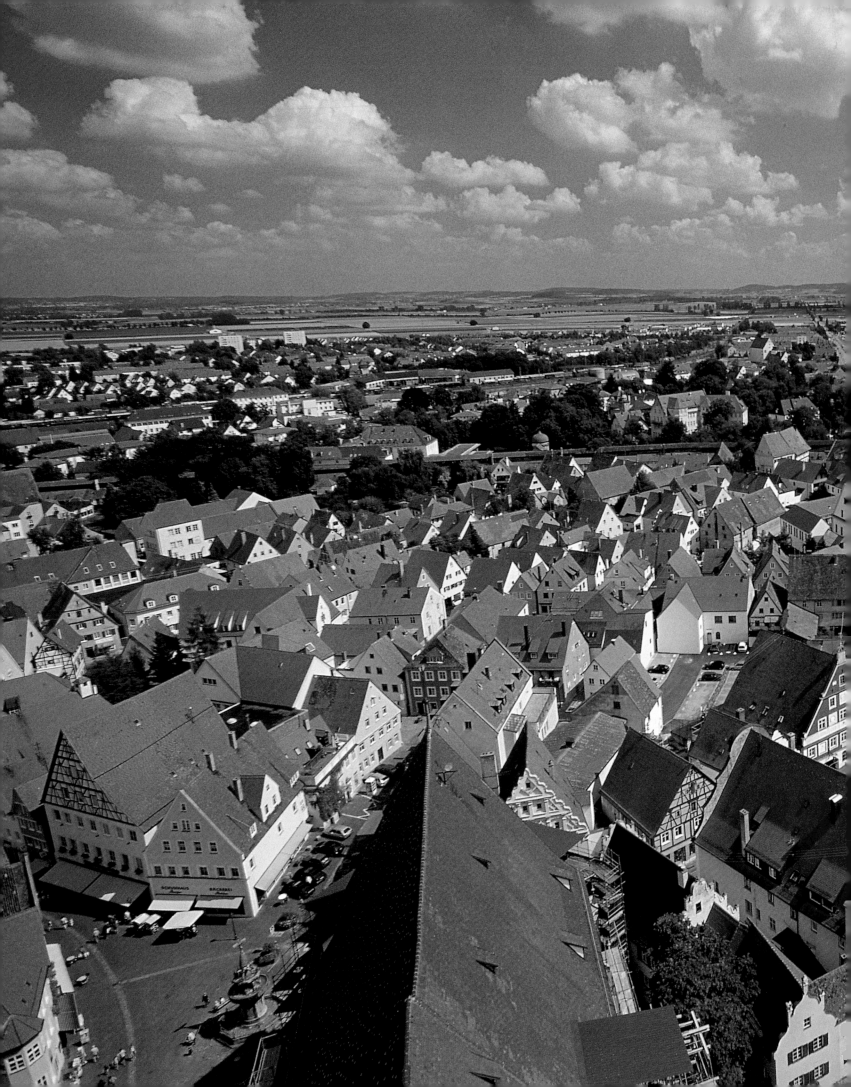

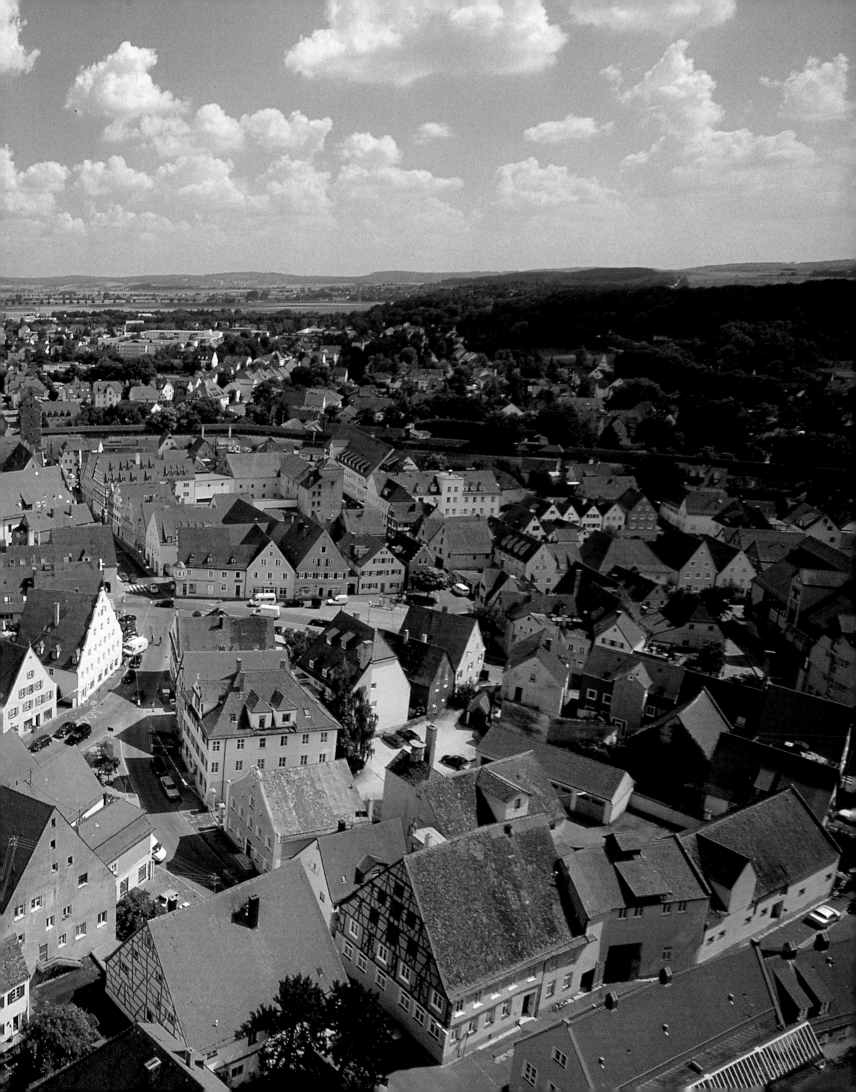

Elias Holl was city architect for Augsburg from 1602 onwards and did the town proud with his many magnificent Renaissance buildings, two of which are the Zeughaus and Rotes Tor. His most splendid bequest is the Rathaus with its Goldener Saal or golden chamber (1615–1620) with Holl's Perlachturm standing erect beside it.

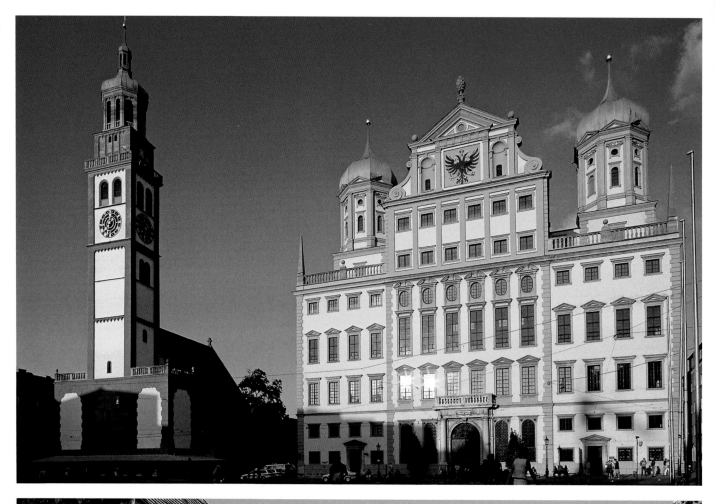

The Fuggers of Augsburg were moneymakers with a conscience. In 1521 Jakob Fugger provided "poor, hard-working citizens" with 106 homes with all the mod cons. Bavaria's first council estate, the Fuggerei, still exists which just goes to show how ahead of its time it was.

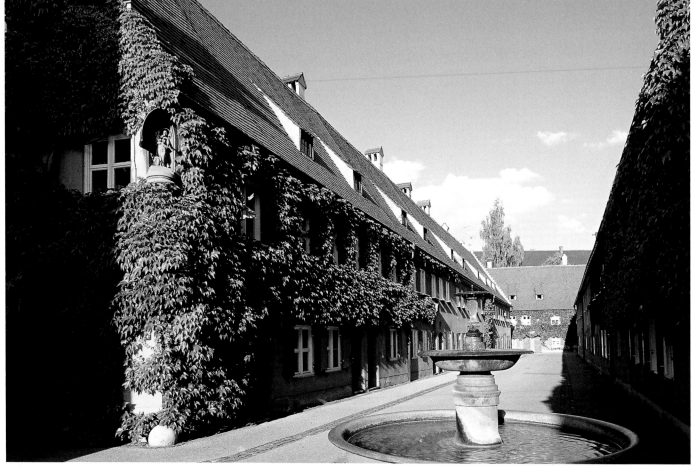

The Kurpark in Oberstdorf pans out in front of the town's parish church dedicated to St John the Baptist. First mentioned in 1141, the much-visited holiday destination is popular for its restorative climate and Kneipp spas – and is also a mecca for ski jumpers and ski flyers.

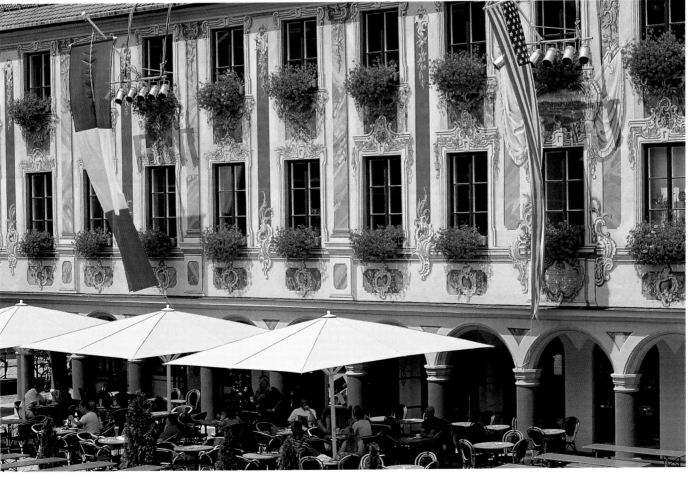

The old free city of Memmingen, once a Roman military post, rose to fame and riches through trade. Its wealthy past has bequeathed to us a pretty old town which is girdled by a sturdy, mile-long town wall. The market place with its tax office of old is particularly impressive.

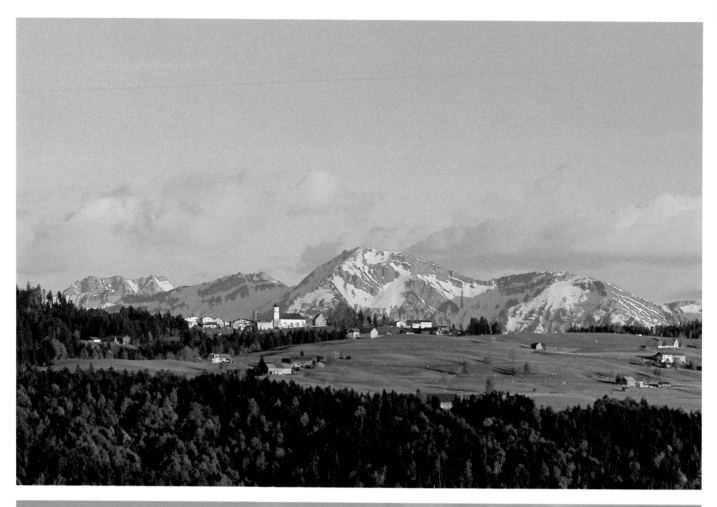

Kneipp spa Scheidegg northeast of Lake Constance is a place of sunshine and glorious panoramic views. The snowy peaks which rise up beyond the town are those of the Sulzberg in Austria.

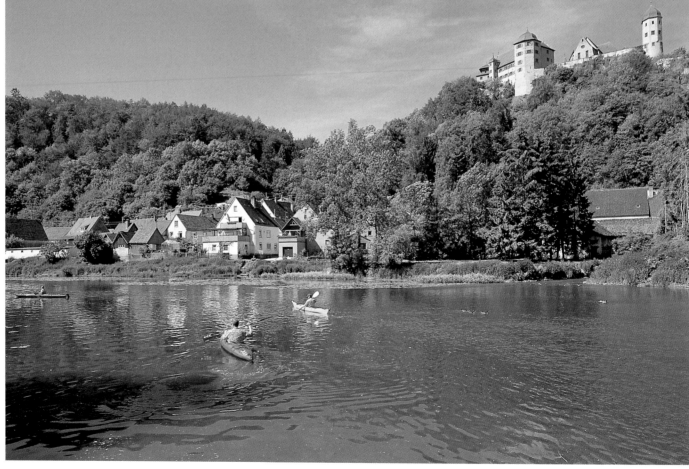

High up above the little town of Harburg is the castle of the same name, first mentioned in the mid 12th century in conjunction with the Staufer dynasty. Around 150 years later it fell into the hands of the Oettingen family and is now an interesting museum with exhibits which range from tapestries to gold jewellery, from ivory work to wood carving.

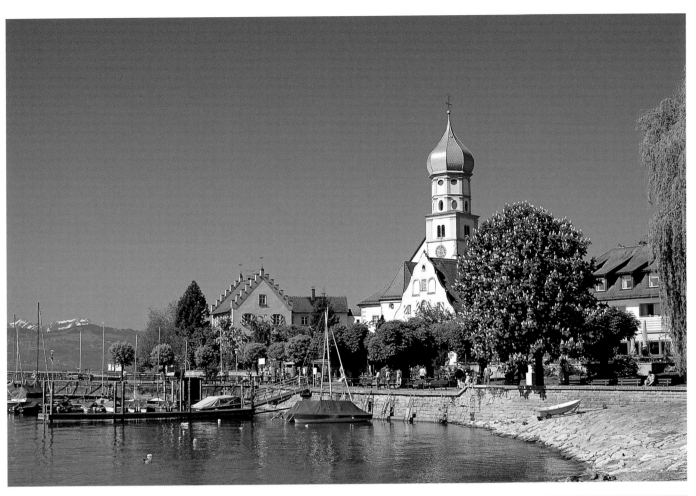

The peninsular of Wasser-
burg west of Lindau is
heralded as the "pearl of
Bavarian Lake Constance".
The town is popular with
water sports fanatics, hikers,
cyclists and also artists.
The castle, now a hotel,
dates back in its present
form to the 15th century;
the church is from the mid
1600s.

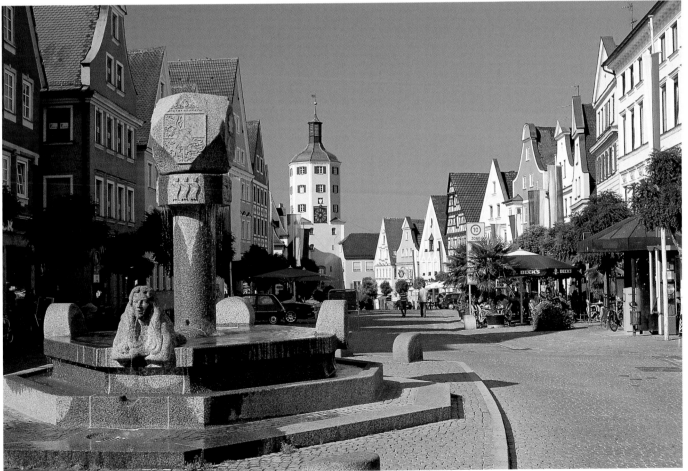

Günzburg, from the
Roman Guntia, was
Austrian from the
14th century until 1805.
Its market square is lined
with gabled houses from
the baroque period. The
Unteres Tor or lower city
gate was completed in
1436 and its turret added
at the end of the 16th cen-
tury.

53

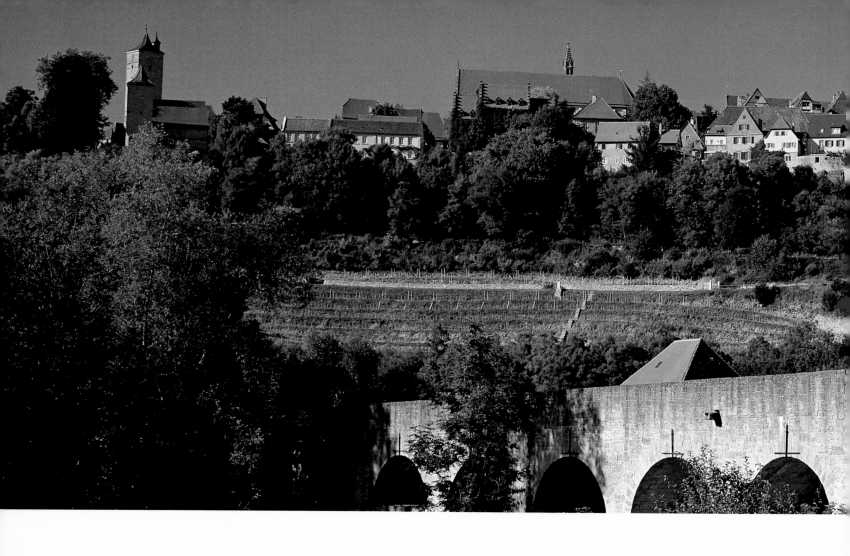

"A land blessed" — Franconia

"Have the Franks as your friends, but never as your neighbours" goes an old Roman saying. Maybe this is what the Bavarians had in mind when at the beginning of the 19th century they annexed the patchwork of states and microstates which was Franconia. This not only solved the problem of neighbourhood but also made a whole out of what were at the time four ecclesiastical states (Würzburg, Bamberg, Eichstätt and the estates of the Teutonic Order), two margravates (Ansbach and Bayreuth), a host of counties (including Henneberg, Schwarzenberg, Hohenlohe and Wertheim), five free imperial cities (Nuremberg, Schweinfurt, Rothenburg, Weißenburg and Windsheim), six knight's cantons and a handful of self-governing villages under the emperor. Despite this 19th-century *Anschluß* the individual towns and regions were largely able to maintain their own identities.

Bayreuth rose to international fame through Richard Wagner's Festspielhaus. Its palaces and gardens are still haunted by the benevolent spirit of Margravine Wilhelmine, Frederick the Great's favourite sister. Würzburg and Bamberg both enjoy a favourable status as UNESCO World Heritage Sites with their residential palace and cathedral respectively. The imperial castle in Nuremberg is also a hot favourite. Although the historic fabric of the city had to be almost completely reconstructed following the Second World War, much of medieval Rothenburg ob der Tauber is still original.

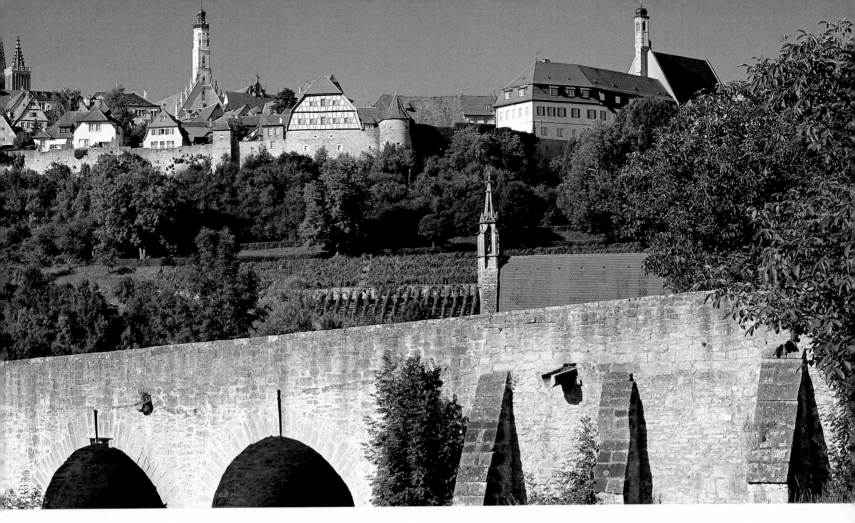

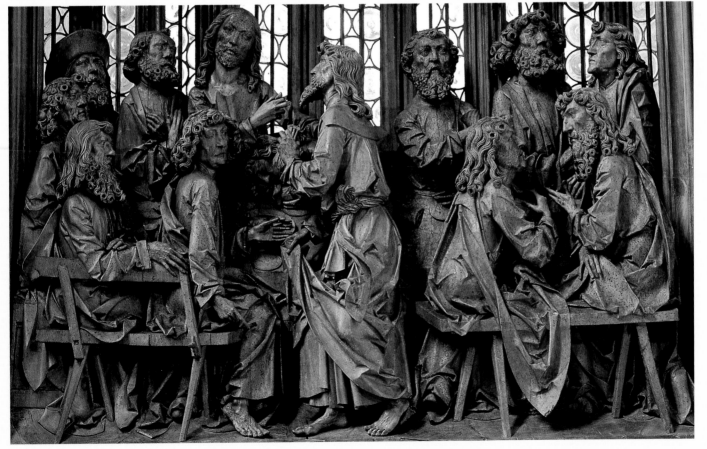

Above:
Right out of your childhood book of fairytales: Rothenburg ob der Tauber. In the foreground the sturdy medieval twin bridge straddles the River Tauber, with lush gardens and vineyards beyond it. At the top of the hill is the town itself, thankfully spared the Allied air raids of 1945 and now as famous in America as it is in Japan and Australia.

Left:
The Altar of the Holy Blood in Rothenburg's parish church of St Jakob represents a high point in the artistic career of Tilman Riemenschneider. The famous Franconian sculptor worked on his masterpiece from 1501 to 1504 which has as its centre panel his interpretation of The Last Supper.

The Domplatz in Bamberg provides an impressive backdrop for the yearly Corpus Christi procession. The cathedral, consecrated in 1237, is the third place of worship to have been erected on this site. Its most famous work of art is the mysterious Bamberger Reiter, a statue of a knight on horseback representing the age of medieval chivalry and kingship.

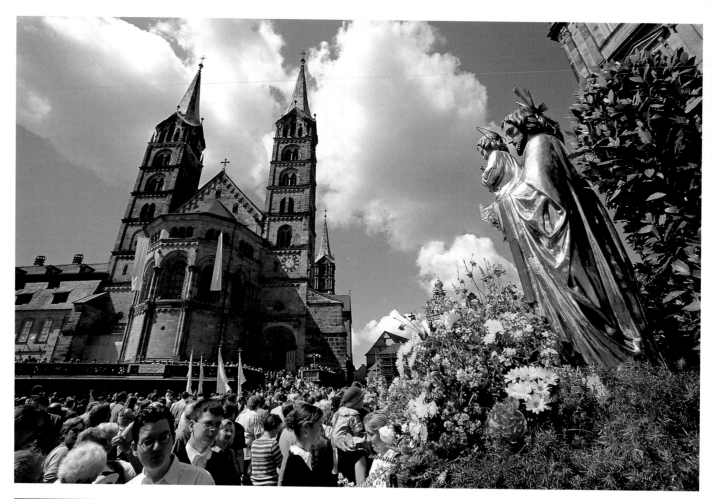

This romantic spot on the River Regnitz is known as Little Venice. The artistic hotchpotch of houses lining its bank, best seen from aboard one of the local pleasure boats, was once inhabited by skippers and fishermen.

Right page:
Bamberg's Altes Rathaus, later painted in baroque patterns and colours by JM Küchel, was built during the 15th century in the middle of the Regnitz which once formed the boundary between the episcopal and non-ecclesiastical sections of town. Its half-timbered addition hangs precariously over the water.

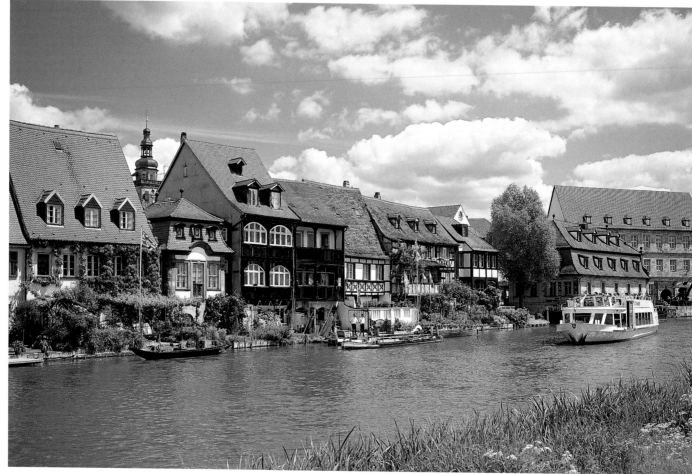

56

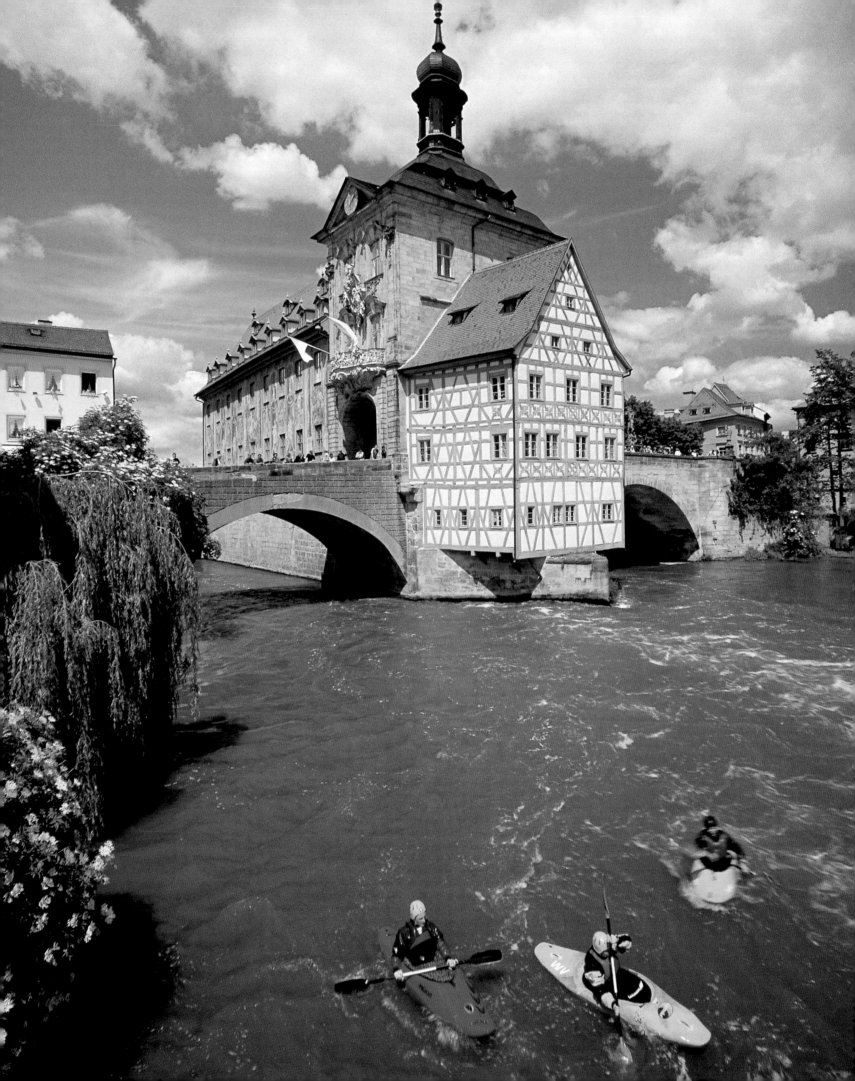

The building of the
Festspielhaus on a hill on
the edge of town in the
1870s inextricably linked
Richard Wagner to the city
of Bayreuth. State guests
and Wagnerians from all
over the world positively
flock to the yearly perform-
ances of his works.

At the beginning of the
18th century Georg
Wilhelm, later margrave of
Bayreuth, had the parks
and gardens of the
Eremitage laid out which
the clever and sensitive
Margravine Wilhelmine
turned into a veritable
temple of the muses. The
fountain outside the Neues
Schloss (1753) is adorned
with mythical creatures
and gods of the sea.

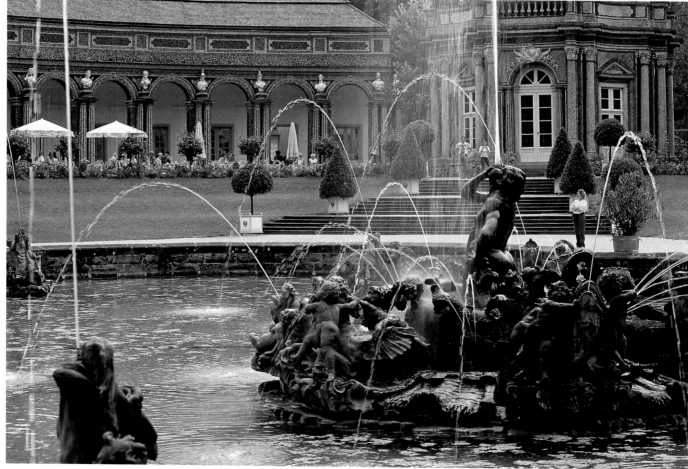

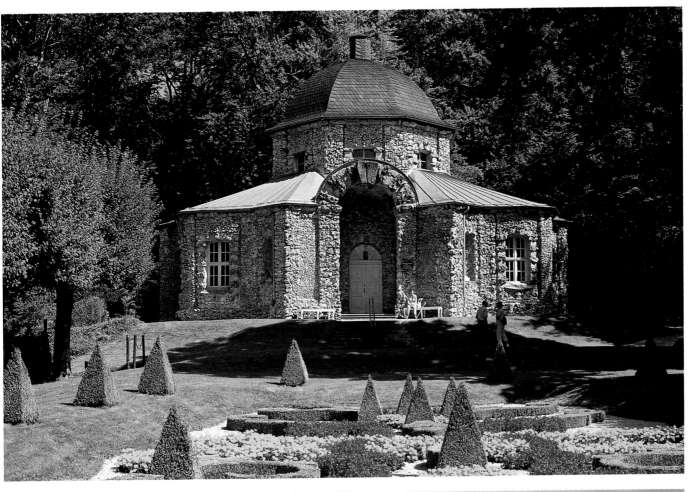

Sanspareil ("without compare") is what Margravine Wilhelmine named her fantastic cliff garden near Burg Zwernitz. Only the oriental pavilion has survived; the margravine's lands were sold off for demolition in later years by King Ludwig I of Bavaria.

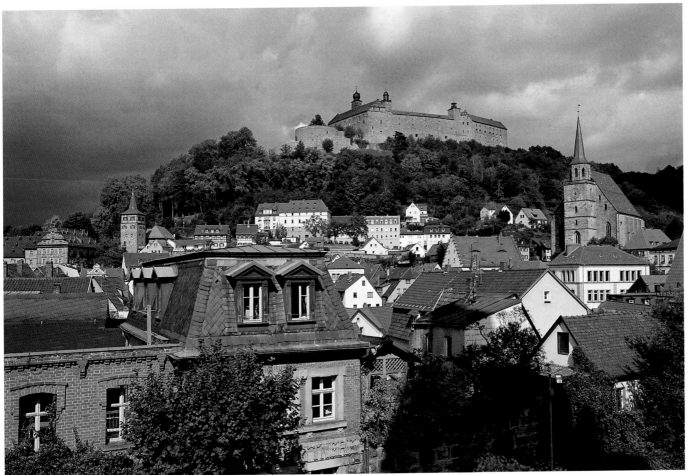

Kulmbach likes to style itself as the capital of beer — not without reason, for the town has an abundance of breweries and also boasts the strongest beer in the world. A mighty strength is also emanated by the massive Plassenburg high up above the town which boasts a marvellous Renaissance courtyard.

Page 60/61:
View of Gößweinstein in the Fränkische Schweiz or Franconian Switzerland, famous for both Balthasar Neumann's pilgrimage church of the Holy Trinity and its fortress, on which the grail castle in Richard Wagner's Parsifal is allegedly modelled.

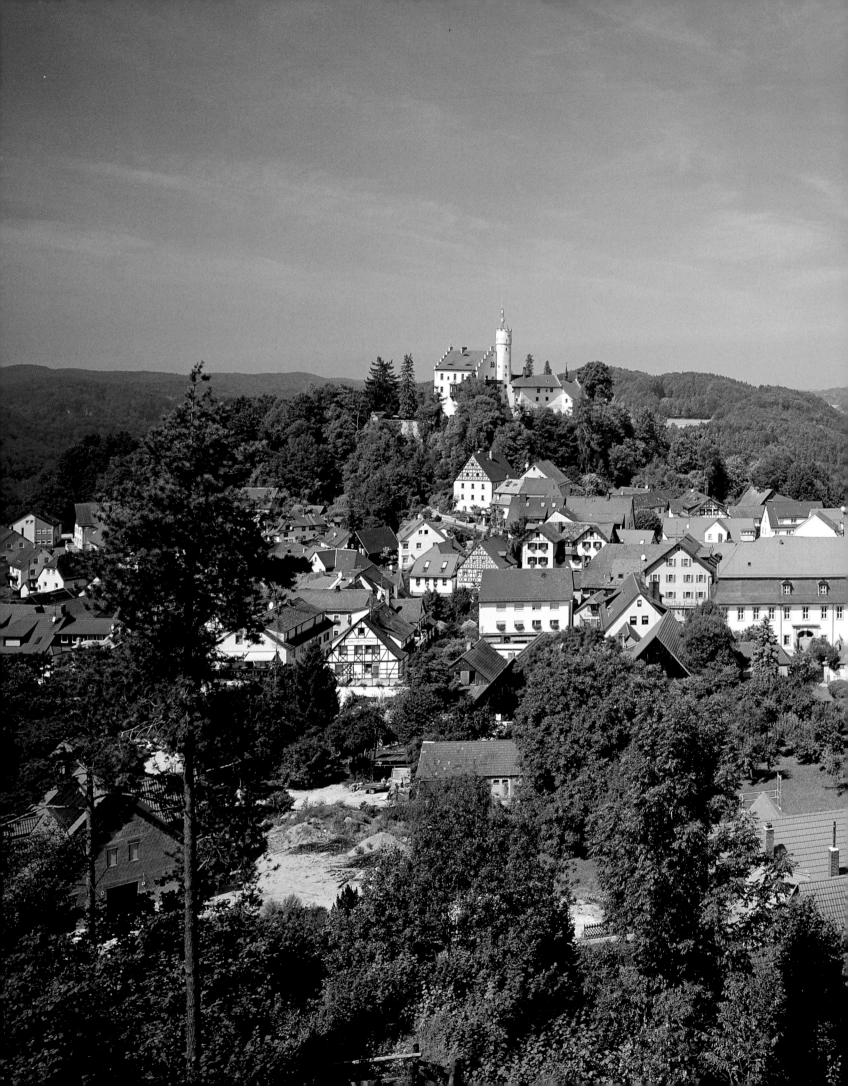

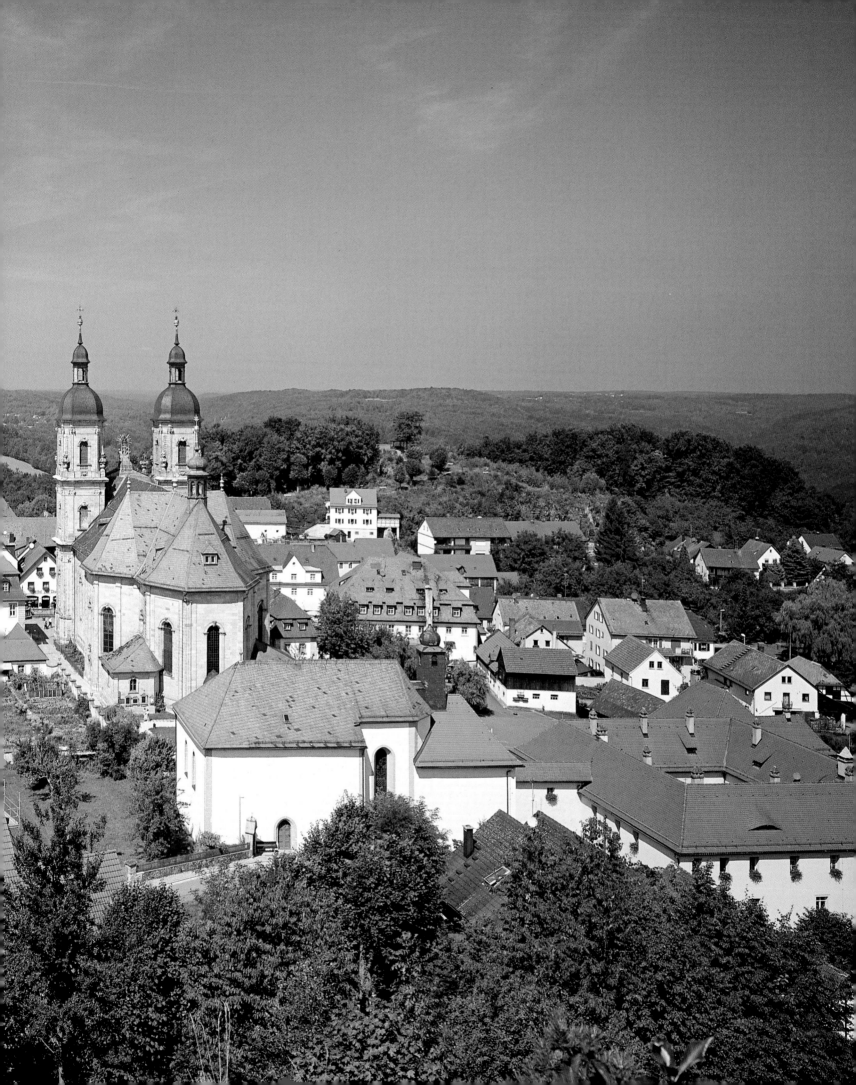

Tüchersfeld is the name of this famous picture post-card village with its twin towers of white rock and smattering of half-timbered houses. A museum devoted to the Fränkische Schweiz is now installed in the buildings which replaced the village's lower fortification of Untere Burg in the mid 18th century.

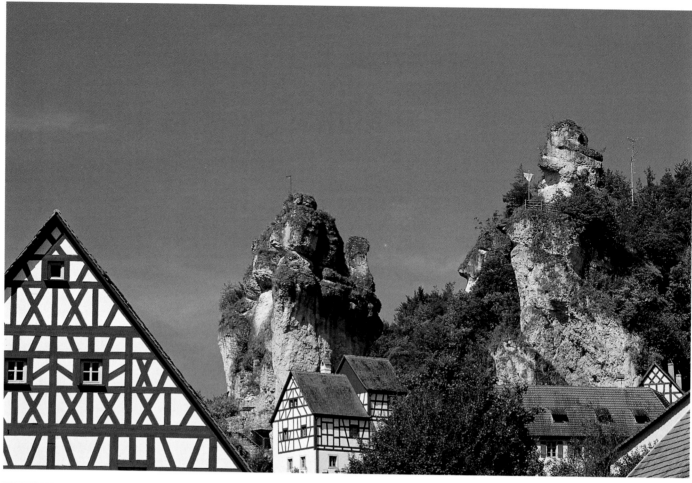

Behringersmühle is one of the most visited places in the Fränkische Schweiz where the streams and rivers of the Ailsbach, Püttlach and Wiesent pool their resources to power a number of mills dotted along their course. Here the idyllically situated Stempfermühle.

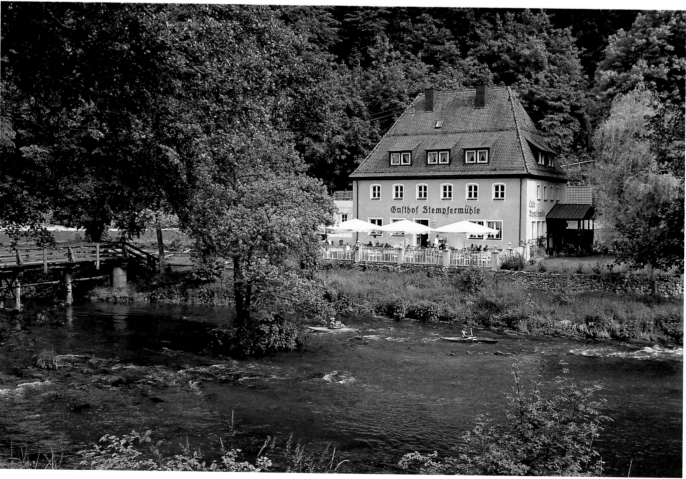

Seßlach with its walls and towers is popular among those of a romantic disposition. Also known as the "Rothenburg of Upper Franconia", the little town not only has a beautiful array of historic buildings but also a very drinkable beer which has been made here at the communal brewery since 1335.

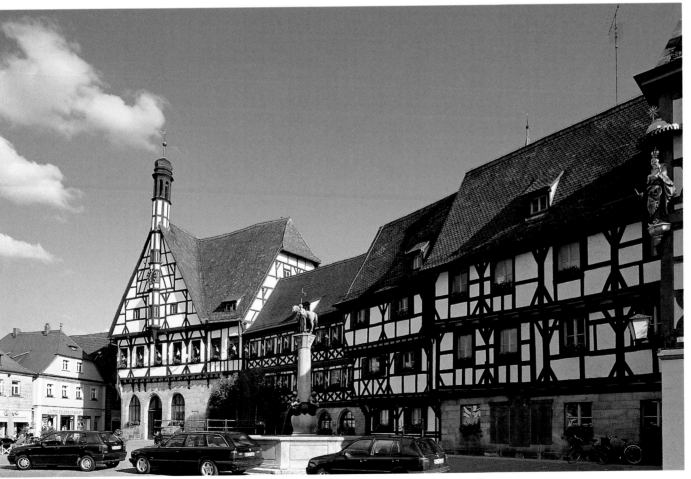

The town hall in Forchheim, with its Gothic nucleus and Renaissance west wing, is lauded as one of the best in Franconia. According to the Guinness Book of Records, in the run up to Christmas it's turned into the biggest advent calendar in the world.

Each year Germany's most famous Christmas market, the Christkindlmarkt in Nuremberg, is opened by the Christ Child from the balcony of the Frauen-kirche, high up above a sea of brightly lit stalls selling food, mulled wine and seasonal gifts.

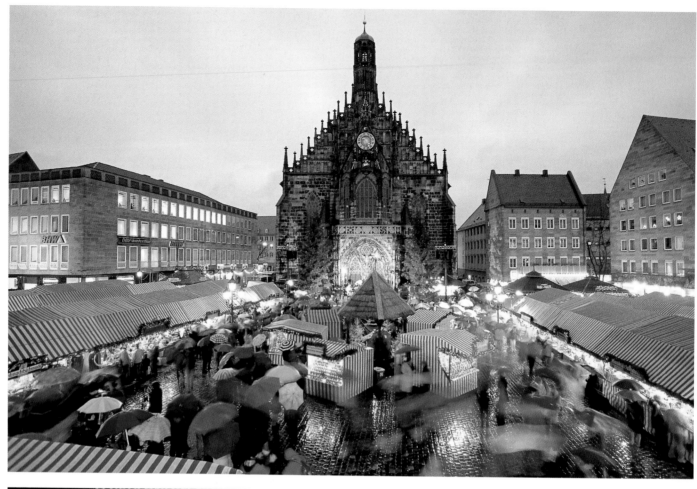

Turning honey, vanilla, candied peel, nuts, spices and chocolate into delicious Lebkuchen or gingerbread is an art the people of Nuremberg have mastered for centuries – the secret of which does not lie in the local "water and air" alone, as GN Schnurtz would have it in his Büchlein der Welt (Little Book of the World) from 1673.

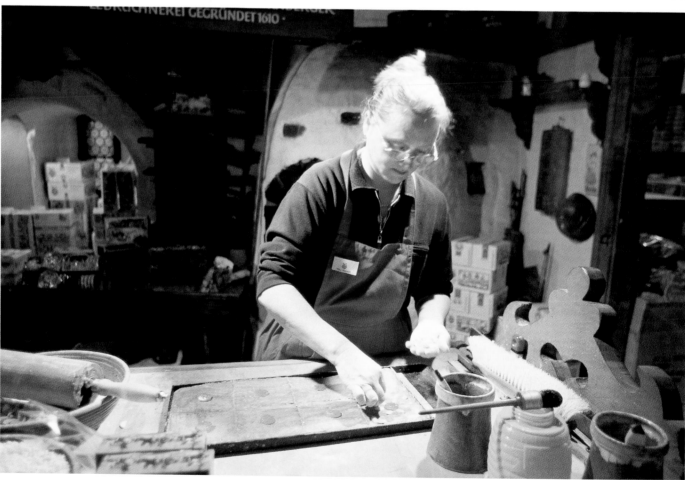

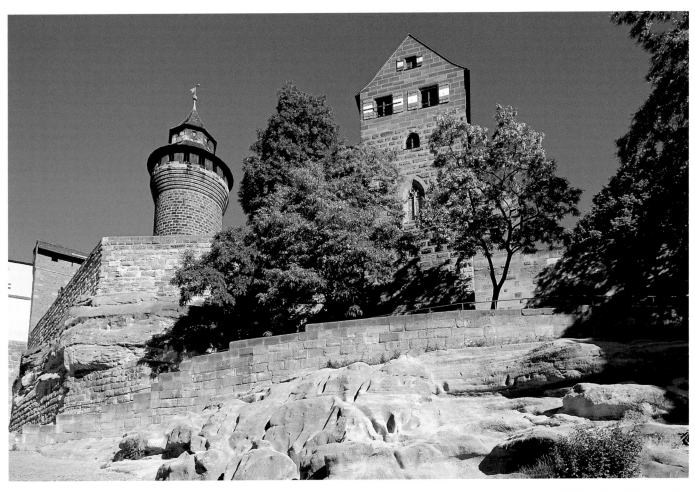

Nuremberg's famous castle is made up of three sections. The most imposing is the castle of the Staufer dynasty, with the fortifications erected by the burgraves and burghers of Nuremberg squeezed onto the narrow sandstone rock beside it. It's no surprise that this conflict of interests in such a confined space often proved explosive…

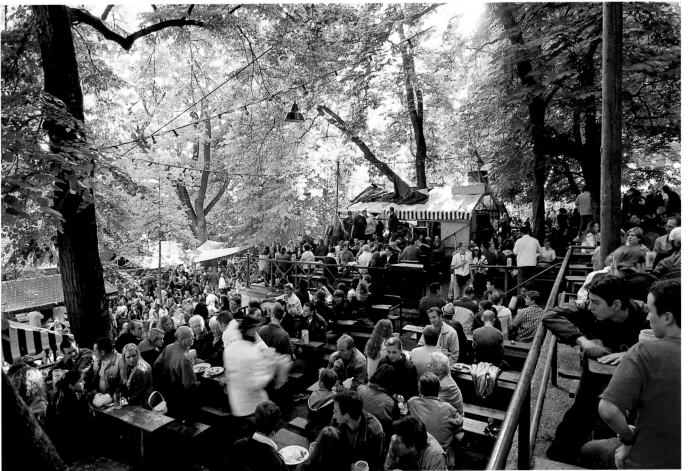

Life hets up during the Bergkirchweih in Erlangen. The festival has existed for no less than two hundred and fifty years. The run on the funfair rides and beer cellars starts on the Thursday before Whitsun and proves so all-embracing with regard to the local populace that even the university is closed for the duration.

At the Reichsstadt-Fest-
spiele in September all of
Rothenburg ob der Tauber
is a stage upon which
the various events of the
town's turbulent history
are re-enacted with
panache and gusto.

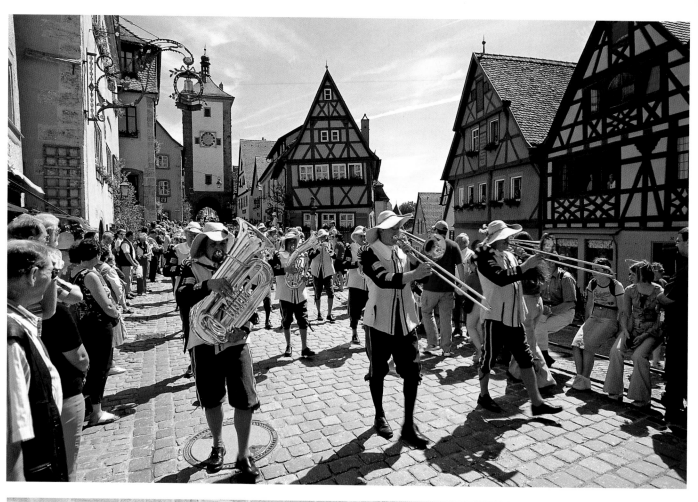

A summer's day in the
old town of Ansbach.
This also has a rich history
which for centuries was
dominated by the bur-
graves and later margraves
(Zollern) of Nuremberg
who had a residential seat
here.

The Ellinger Tor, the gateway built as part of the town defences during the 14th century, is Weißenburg's local landmark; its Roman museum, however, is the main attraction. Here the biggest find from this period in Germany is on display: over one hundred magnificent examples of Roman handicraft.

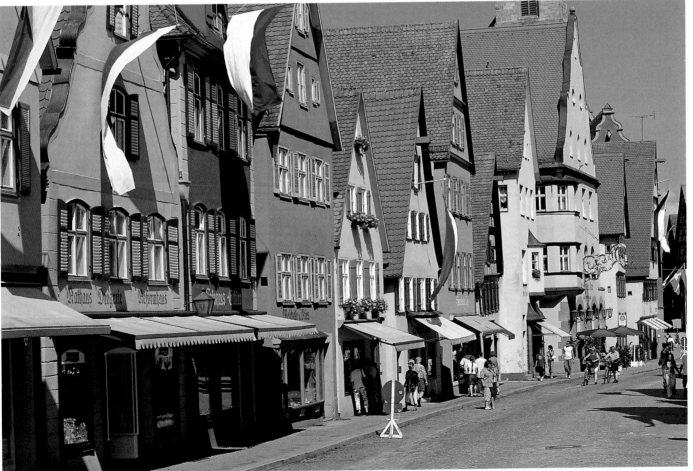

Dinkelsbühl started out as the royal seat of Carolingian kings; today the town is one of the most popular destinations on the Romantische Straße. Over half of its historic buildings are over 400 years old; here Segringer Straße with its many beautiful houses.

Page 68/69:
There are grand views from the Festung Marienberg in Würzburg. To the left of the picture is the Alte Mainbrücke, the old bridge across the Main. This was just one of the many edifices reconstructed following the almost total annihilation of the city during the British bombardment of March 16, 1945.

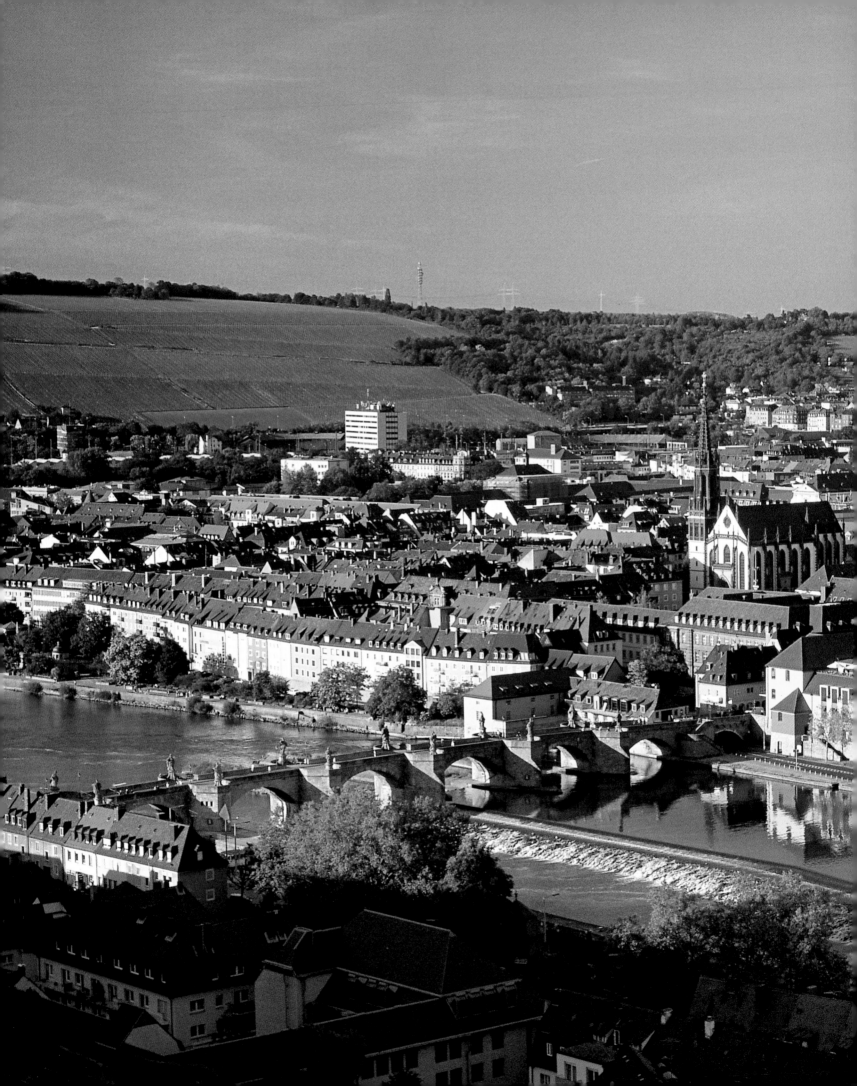

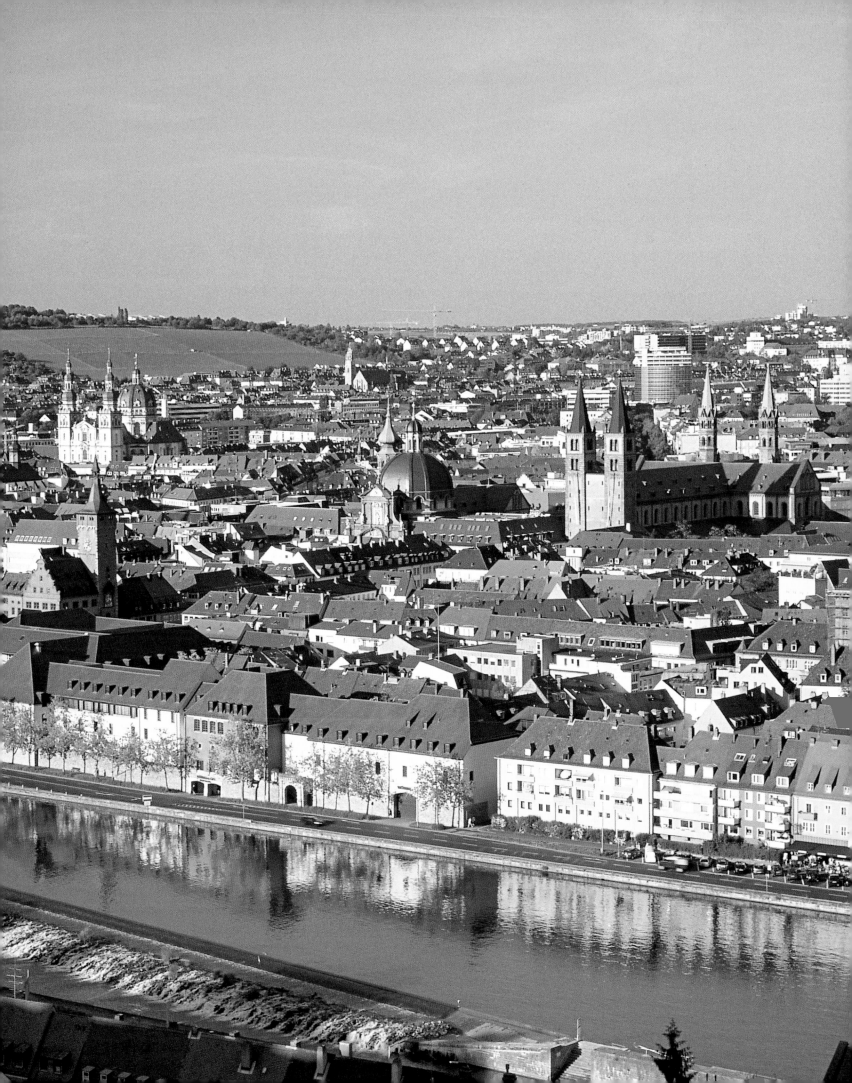

The towers of Würzburg in the evening sun. Just beyond the Alte Main-brücke is Grafeneckart, the seat of the episcopal mayors during the Staufer period which later became the town hall. The twin steeples to its right belong to the Kiliansdom, one of the biggest Romanesque cathedrals in Germany.

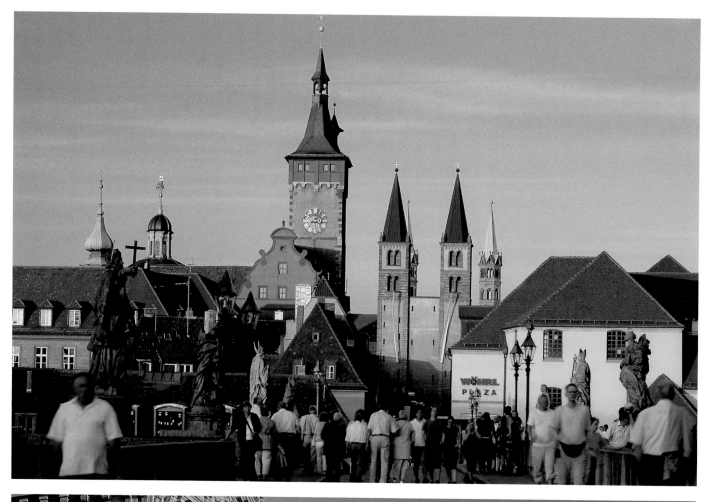

The baroque Residenz in Würzburg was made a UNESCO World Heritage Site in 1981. The palace was built by Balthasar Neumann – who at that time was a nobody. The fountain of Franconia in the Court of Honour was erected in celebration of the 70th birthday of Prince Regent Luitpold in 1894.

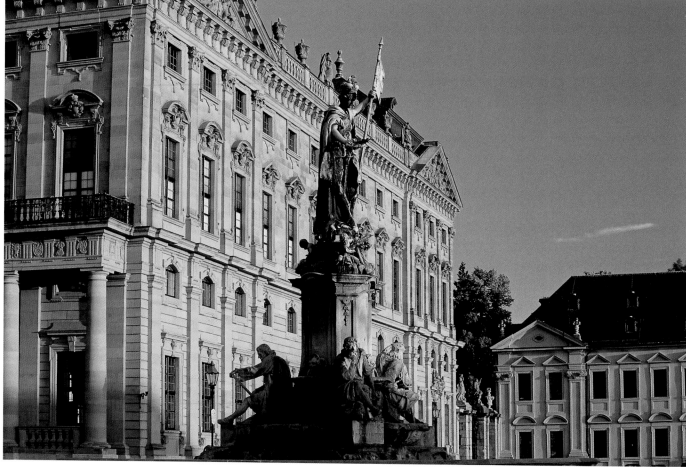

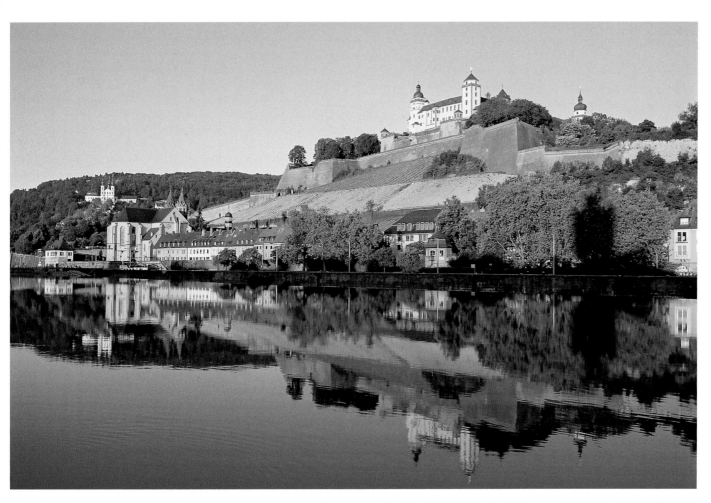

The graceful counterpart to the mighty fortress of Marienberg is the Käppele pilgrimage chapel constructed by Balthasar Neumann on the nearby Nikolausberg. The old monastery down on the River Main is dedicated to St Burkard.

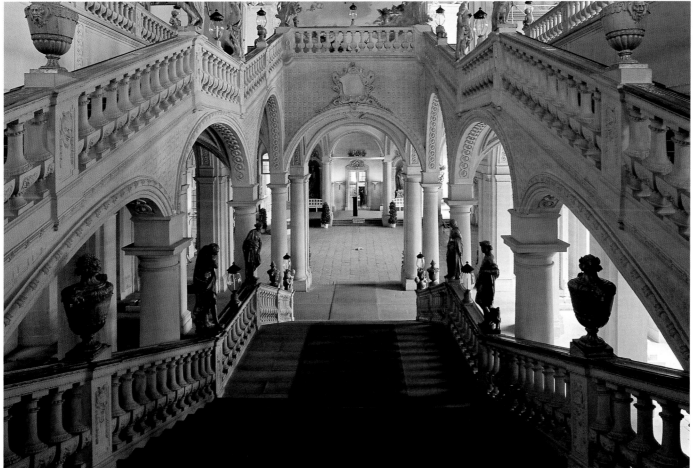

The absolute highlight of the Würzburg Residenz is the staircase with its unsupported vault, lavishly frescoed by the famous Venetian artist Giovanni Battista Tiepolo. At 650 square metres (almost 7,000 square feet) his work is the largest ceiling painting in the world.

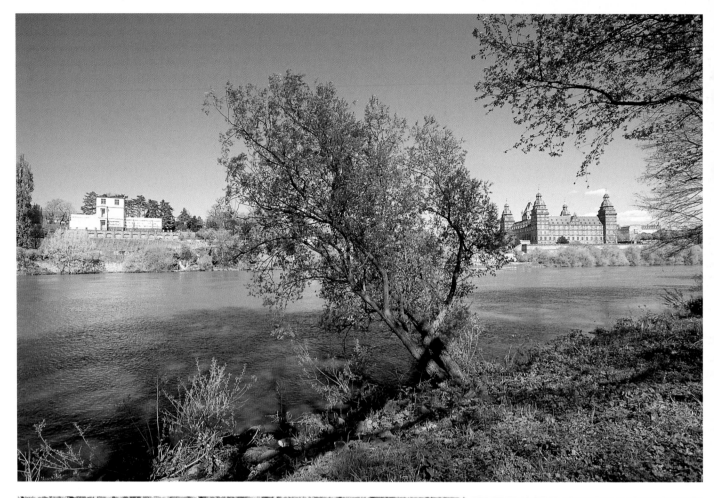

Aschaffenburg. View across the River Main of Schloss Johannisburg, a mammoth Renaissance palace of red sandstone built between 1605 and 1614 from plans by Georg Ridinger from Alsace. The 'Roman' villa created for King Ludwig I between 1840 and 1848 (far left), is positively modest in comparison.

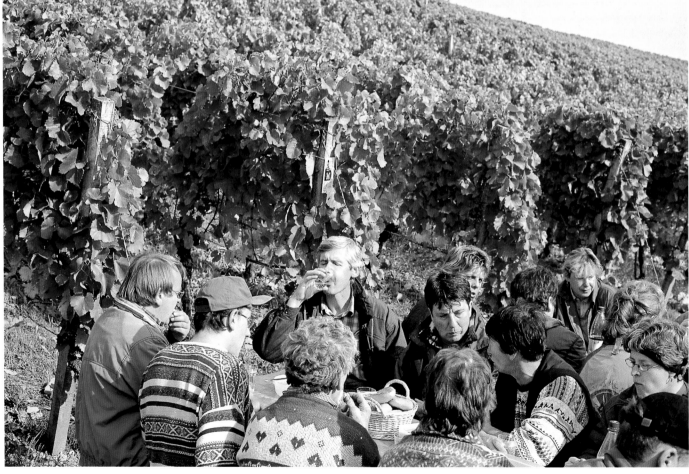

The biggest event in the vinicultural calendar is the grape harvest, in which the first prognoses as to the quantity and quality of the year's vintage can be made. Harvesting the crop by hand is hard work; a hearty lunch is always welcome, being enjoyed here by the helpers of Weingut Pfeuffer in Frickenhausen.

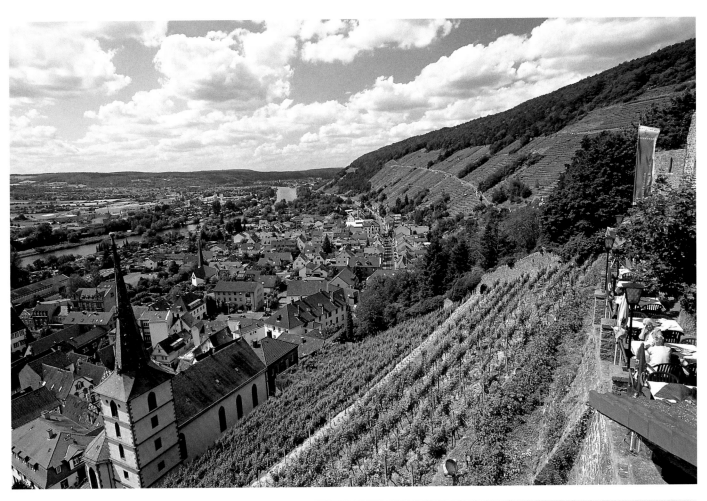

View from the ruined castle of Clingenburg of the little town of the same name which, as the following ditty suggests, has always been a good place for (red) wine: "In Klingenberg on the Main, / In Bacharach on the Rhine / And in Würzburg on the Stein / There grows the finest wine."

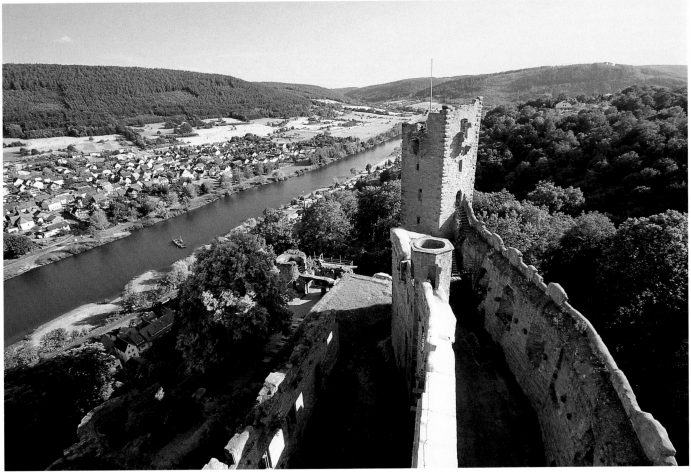

The enormous ruin of Henneberg tottering high up above the town of Stadtprozelten first belonged to the counts of Wertheim and then the Teutonic Order of Knights. From its sturdy walls there are good views out over the Main Valley.

73

LOWER BAVARIA AND THE UPPER PALATINATE – THE EAST

Besides the medium-range hills of the Bayerischer Wald with its great forests and cold snowy winters the Danube also characterises much of Lower Bavaria. The Gäuboden with its expanses of fertile meadows is the "granary of Bavaria". Here in Straubing is where the heart of Old Bavaria beats the strongest, cushioned by an army of splendid baroque monasteries and churches, such as those at Metten, Niederaltaich and Osterhofen-Altenmarkt. The Danube also flows between two city gems, one of them being Regensburg which for one-and-a-half centuries was the venue of the Perpetual Imperial Diet and thus de facto the capital of the Kingdom of Germany in the Holy Roman Empire. The city is proud of its history and of its 20 medieval high-rise towers, the former dwellings of mighty local families on a par with San Gimignano in Tuscany. The other is Passau which is even more Mediterranean, built, formed and decorated by architects, painters and stucco artists deploying skills learned in their homelands of Upper Italy and Tirol. The city also boasts no less than three rivers in the Danube, Inn and Ilz.

Like Lower Bavaria the Upper Palatinate only became popular with holidaymakers and daytrippers in the wake of the Second World War. The increasing number of visitors has since learned to appreciate this unadulterated stretch of countryside, once described as the "poorhouse of Bavaria". The biggest tourist magnet in the area is without doubt the Drachenstich festival which takes place in Furth im Wald every year.

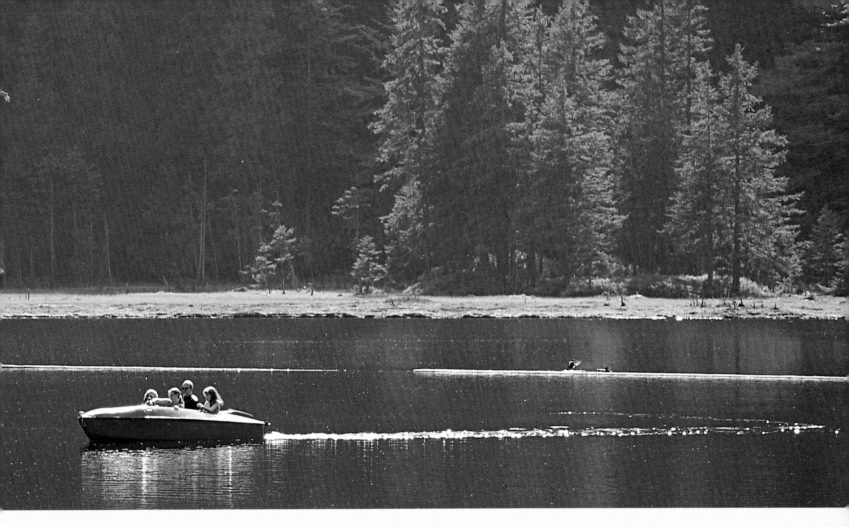

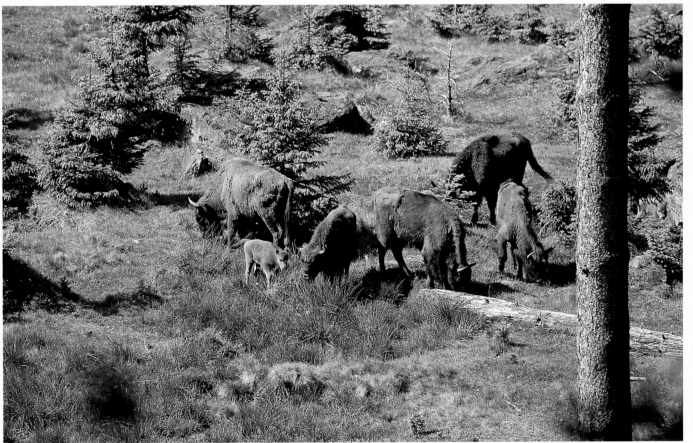

Above:
Even if it only beats
Mount Rachel by a mere
three metres, the Großer
Arber in the Bayerischer
Wald or Bavarian Forest
is the tallest in the land at
1,456 metres (4,777 feet)
above sea level. Beneath
its slopes lie the serene
waters of the Großer
Arbersee.

Left:
The Bayerischer Wald
National Park was founded
in 1970 and extended
to cover an area of over
24,000 hectares
(59,304 acres) in 1997.
Bears and wolves, extinct
by the mid 19th century,
and also lynx and bison
can once again be found
here cohabiting with their
human neighbours.

The streets of Old Regensburg are extremely narrow and often little more than alleyways. While offering protection the old town walls were also restrictive, leaving hardly any room for roads and housing.

View of the Thurn and Taxis palace courtyard in Regensburg. The spacious complex has many splendid state rooms, including the magnificent Spiegelsaal or hall of mirrors and the library of the old St Emmeram Monastery with its frescoes by Cosmas Damian Asam.

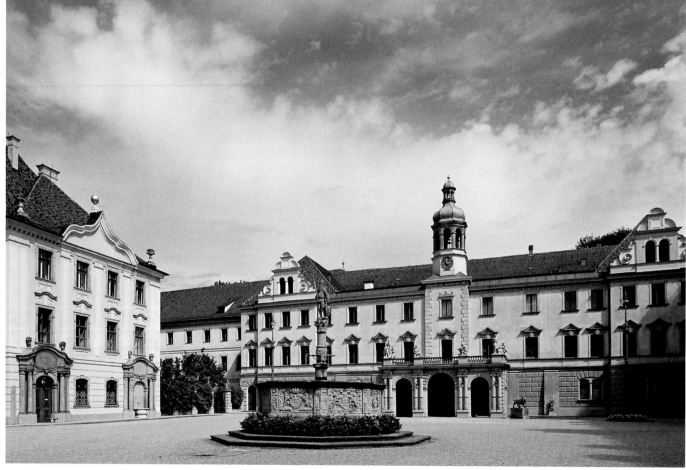

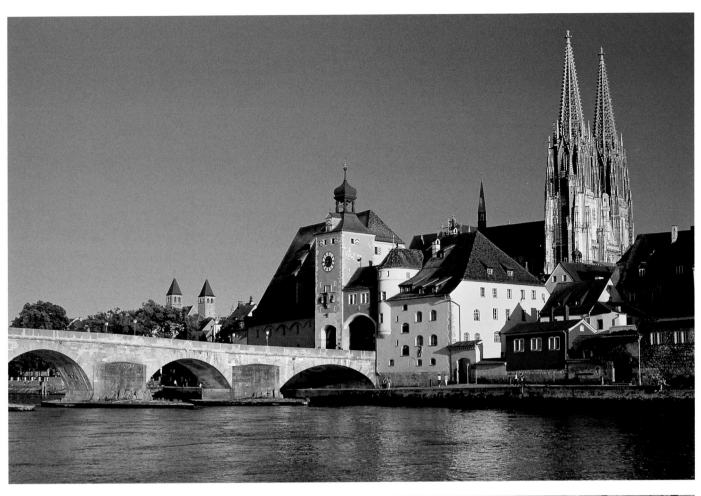

The long stone bridge
through the middle of
Regensburg is a staggering
850 years old, with the
Brücktor gate and Salz-
stadel building not much
younger. The oldest edifice
in town is, however, the
cathedral of St Peter's,
begun in the mid 13th cen-
tury.

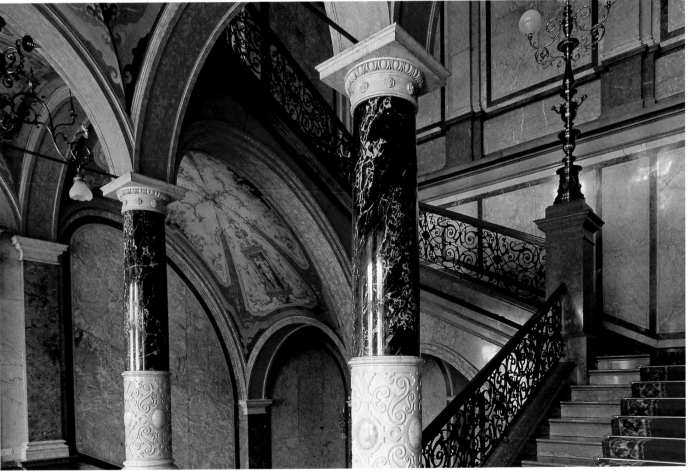

Staircase at the palace of
the princes of Thurn and
Taxis who set up the first
postal service in Western
and Central Europe. The
dynasty moved to Regens-
burg on Prince Alexander
Ferdinand being made the
permanent representative
of the emperor at the
Perpetual Imperial Diet
in 1748.

The Walhalla monument instigated by King Ludwig I and built by Leo von Klenze near Donaustauf holds the busts of famous Germans, among them Goethe, Schiller, Leibniz, Kant, Haydn, Gluck, Friedrich II of Prussia and Maria Theresa, all deemed worthy of a place by the then monarch of Bavaria.

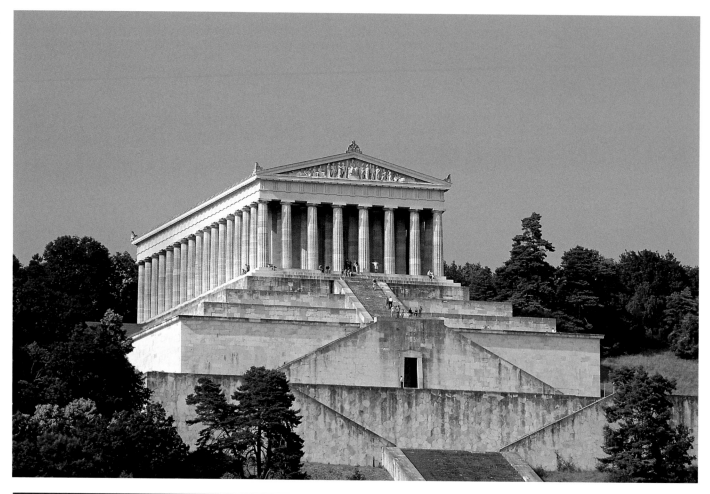

Nabburg towers high up above the river which gave it its name. The "Jerusalem of the Upper Palatinate" was fortified as early as in the 10th century; the two defensive towers which still remain date back to the early 15th century. The town's chief landmark is the parish church dedicated to St John the Baptist from the first half of the 14th century.

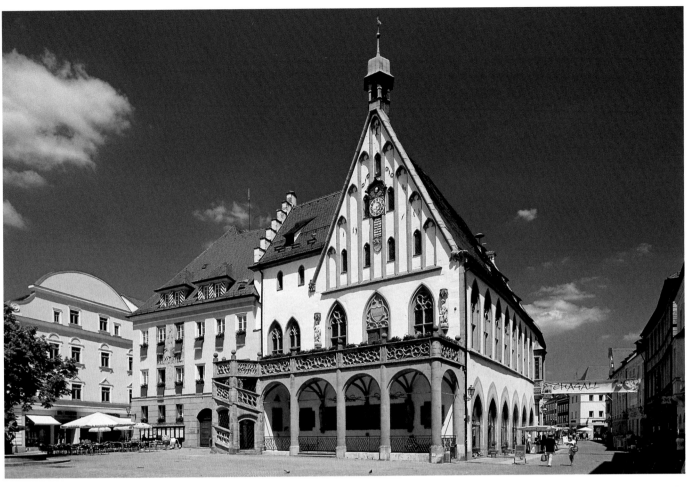

First mentioned in a document by Konrad II in 1034, Amberg was granted its town charter in the mid 12th century. As befits the former residence of the electors, the town hall is suitably ornate, with an elaborate gable and arcade flanking the commodious market place.

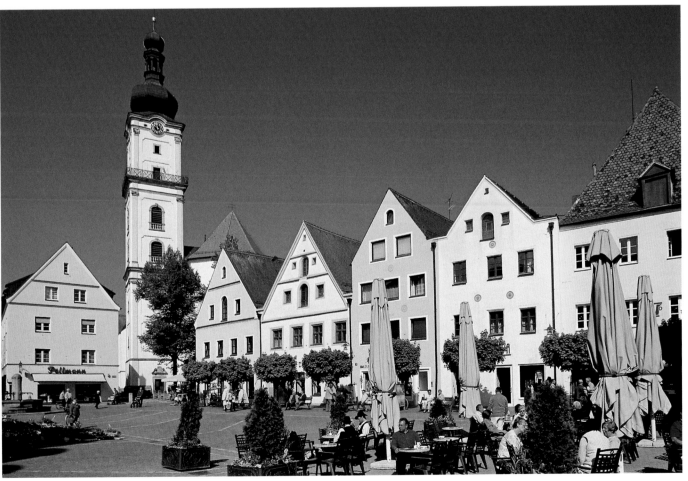

Weiden, the provincial centre of northeastern Upper Palatinate, first boomed under Emperor Karl IV who had the "golden route" from Prague to Nuremberg run through the town. The elongated market place is overseen by the Lutheran parish church of St Michael's, completed in 1448 and refurbished in baroque 200 years later.

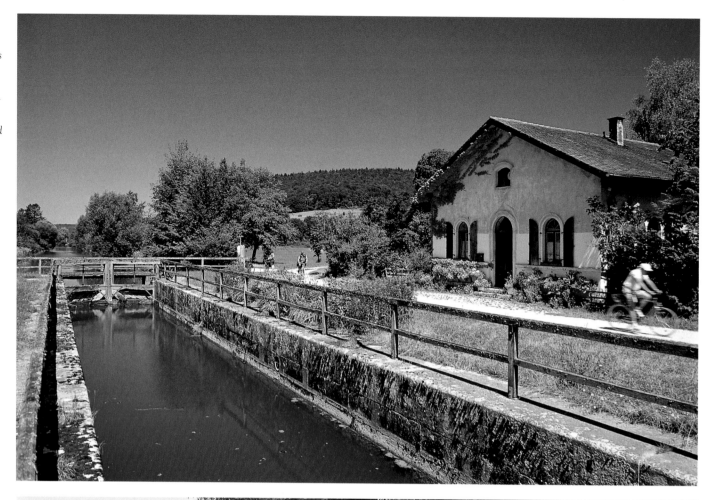

Locks near Dietfurt in the valley of the Altmühl. Emperor Charlemagne was the first to attempt a canal linking the Main and Danube; 1,000 years later King Ludwig I of Bavaria proved more successful and his brand new waterway between Bamberg and Kelheim was opened in 1846.

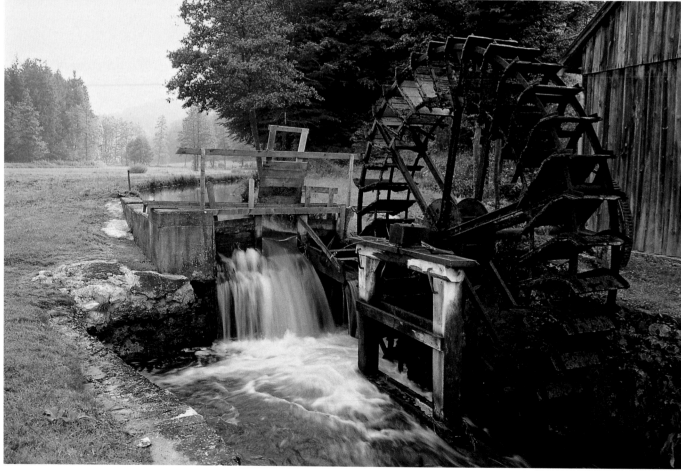

The Biermühle (beer mill) on the Weiße Laaber has an unusual name. It is situated near Berching, a pretty little town dating back to 883 which is still 'fortified' by its medieval walls and turrets.

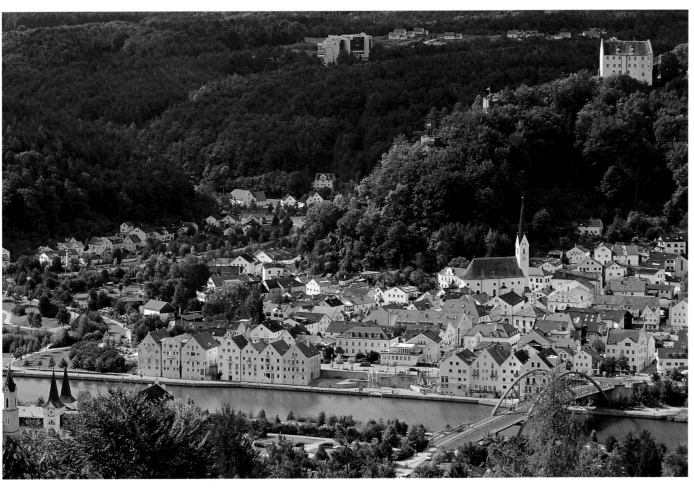

View of Riedenburg in the Altmühltal which has no less than three castles to its name. One of the lords of the Rosenburg was the talented burgrave of Riedenburg who excelled in both swordmanship and song.

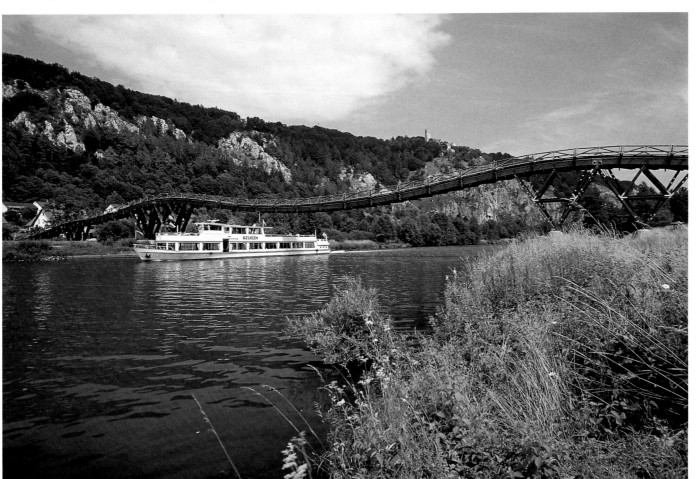

The market town of Essing is squeezed in between the Altmühl and a sheer wall of rock. It's famous for its wooden bridge, the largest in Europe, which snakes across the river, and the ruined castle of Randeck which is almost 900 years old.

Page 82/83:
From the pilgrimage church of Mariahilf Passau lies spread out before you, with its cathedral, old episcopal palace, town hall, former Jesuit church of St Michael's and monastery of Niedernburg. The hill opposite is crowned by the Veste Oberhaus.

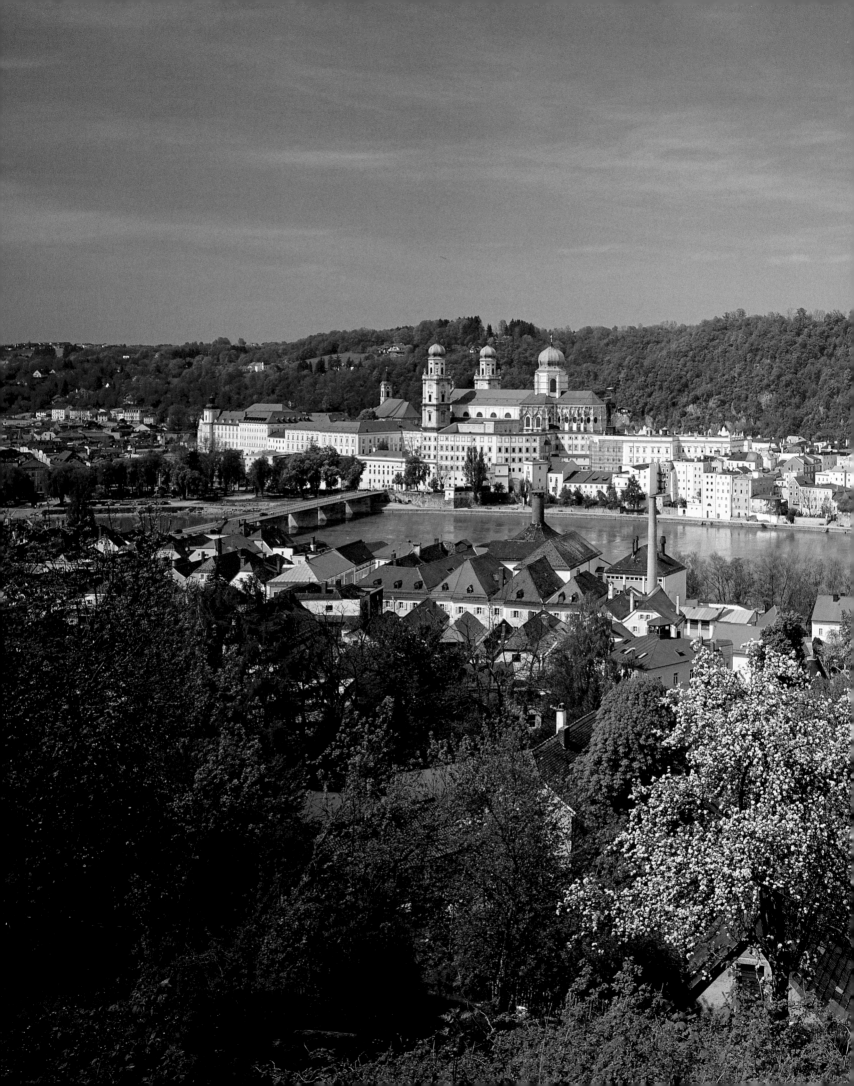

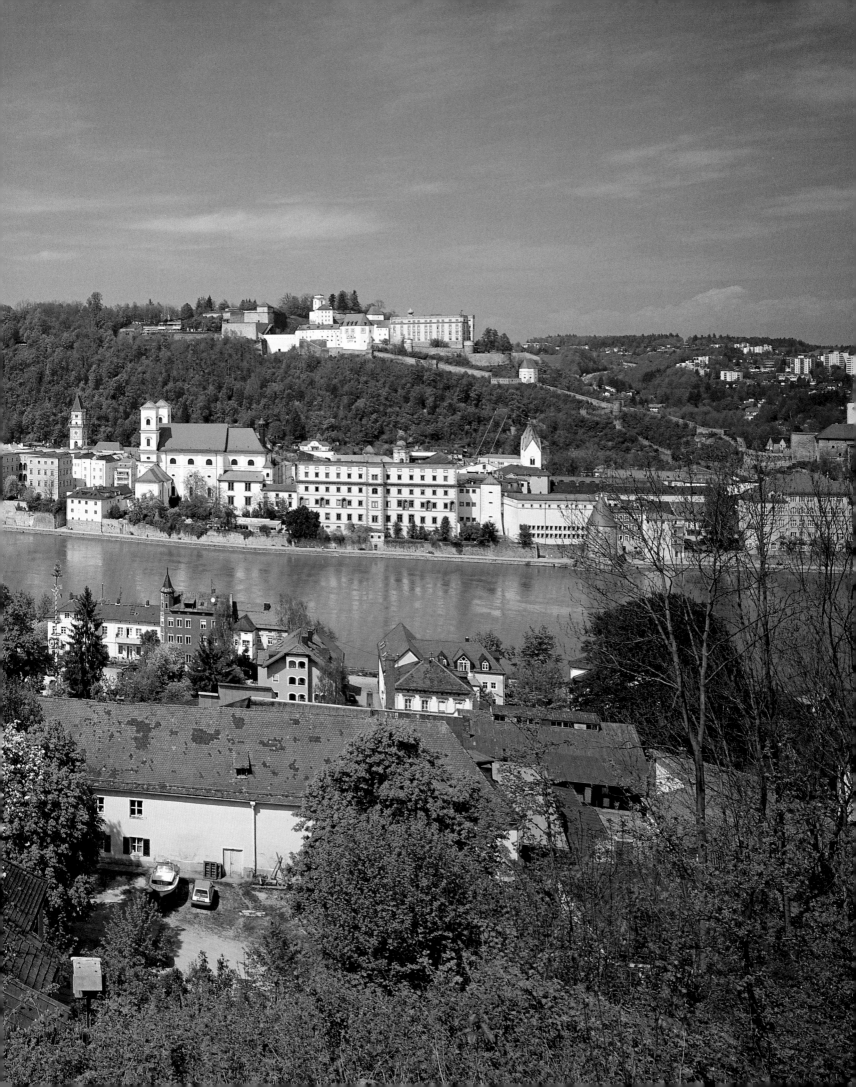

In the Bavarian calendar the Gäubodenfest in Straubing, held each year in the middle of August, is second only to Munich's Oktoberfest. The present town evolved from a Roman camp and the 6th-century Baiuvari settlement of Strupinga.

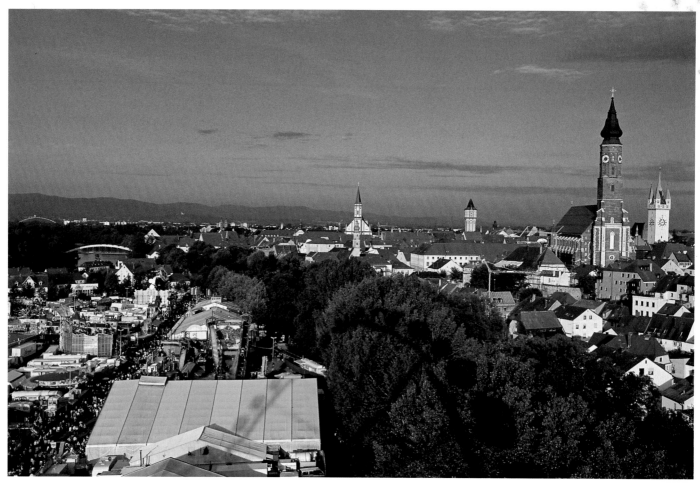

As at the Oktoberfest beer plays a major role at the Gäubodenfest in Straubing. Getting huge mugs of it from pump to punter is hard work – calling for stamina and a sunny disposition.

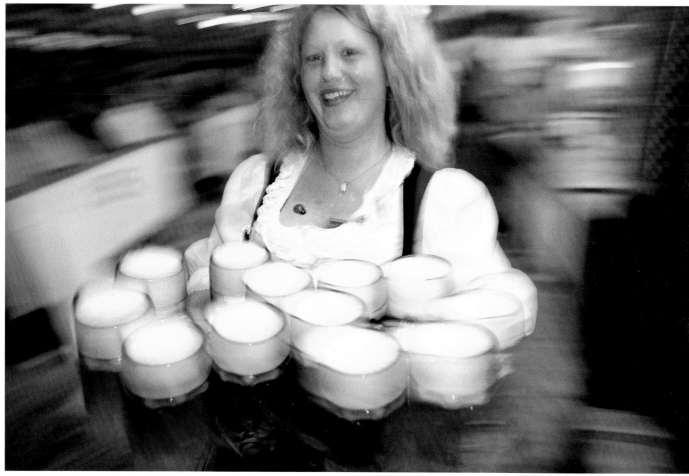

84

Deggendorf near the confluence of Isar and Danube was first mentioned ca. 1,000 years ago. Its main thoroughfare doubles as a spacious street market, culminating in the town's gabled Rathaus from 1535 and huge watchtower behind it.

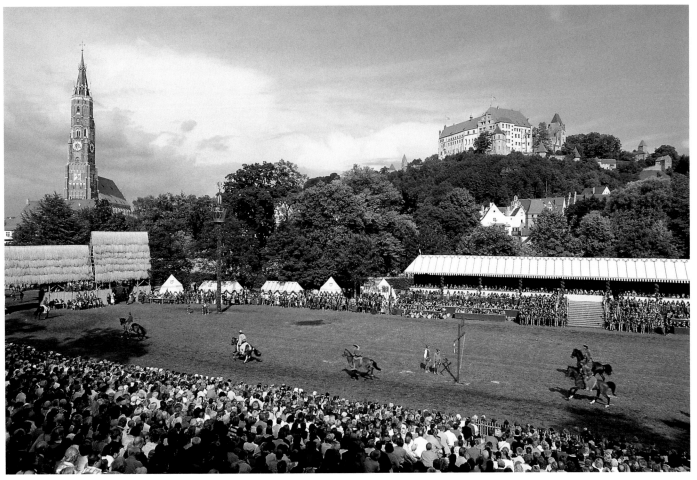

The original Landshut wedding between the daughter of the Polish king, Hedwig, and Duke Georg the Rich of Bavaria in 1475 was a lavish affair – as is the theatrical re-enactment of the event which takes place every four years here. One of the main attractions is the medieval jousting.

Idyllic Rottal enjoys a scenic setting. The pilgrimage church of St Wolfgang is part of Bad Griesbach which on the discovery of hot springs here spiralled to fame as a leading spa practically overnight – together with its equally rural neighbour Birnbach.

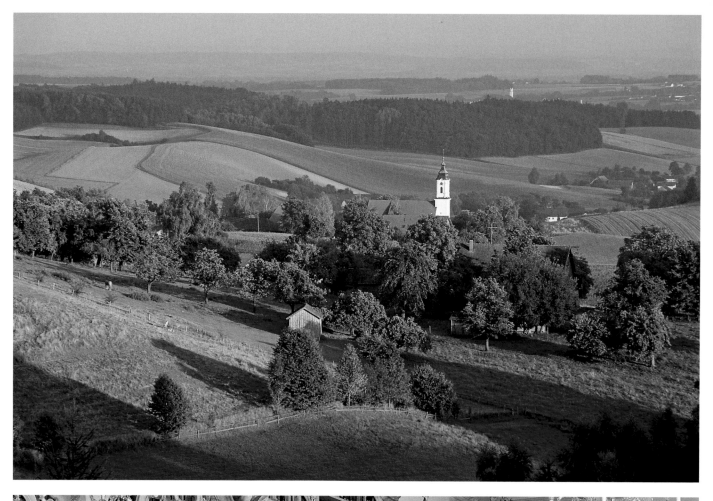

The old Cistercian monastery of Fürstenzell in the Bäderdreieck region of Lower Bavaria was founded in 1274. The present place of worship and other buildings date back to the mid 18th and end of the 17th centuries. The wonderful library is the work of Joseph Deutschmann.

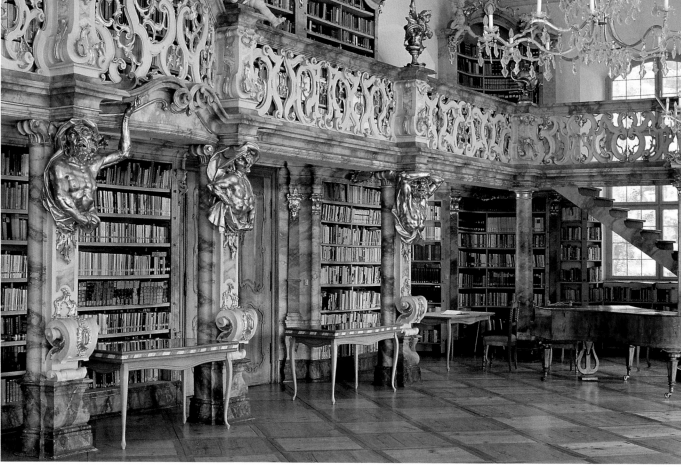

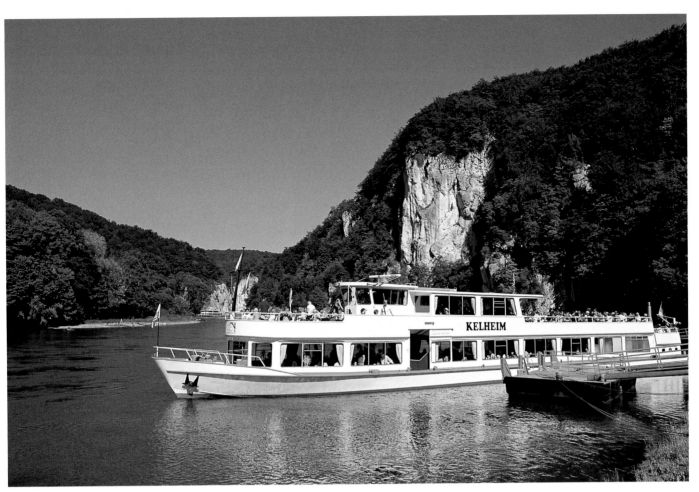

Over the course of millions of years the River Danube has chiselled its way through the mountainside near Weltenberg to create a fantastic natural spectacle which pulls in the crowds year in, year out.

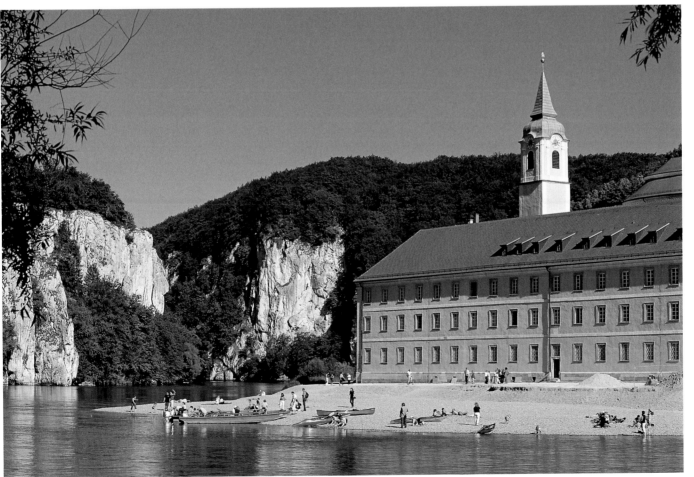

Kloster Weltenburg in the Danube Gorge, its splendid church designed by the Asam brothers, has both a beautiful and precarious setting. Frequent flooding poses a not insignificant danger to the monastery and new barriers are now being erected to help prevent disaster.

Since the installation of the cable railway the Zwieseler Hütte on the Großer Arber has enjoyed an increase in custom in both summer and winter, with the summit of the mountain just a few steps away from the chalet. In fine weather – and with a bit of luck – you can see as far as the Alps.

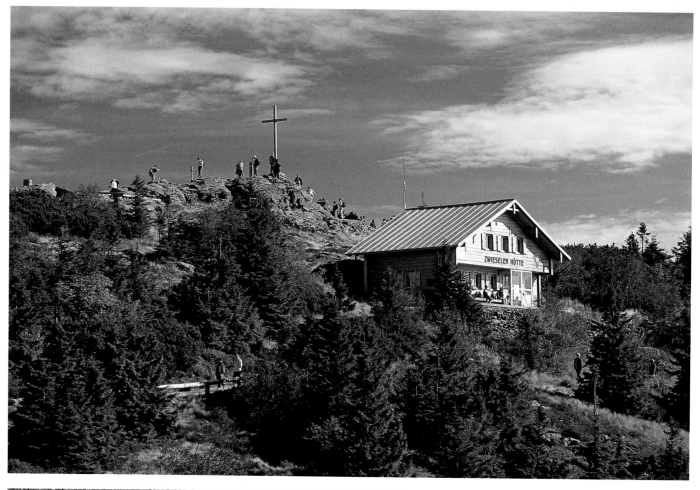

The Bayerischer Wald is full of enchanted places, such as the Buchberger Leite near Freyung depicted here. The aboriginal and relatively unspoilt scenery is one of the greatest attractions of this oldest and largest section of forest on the Continent.

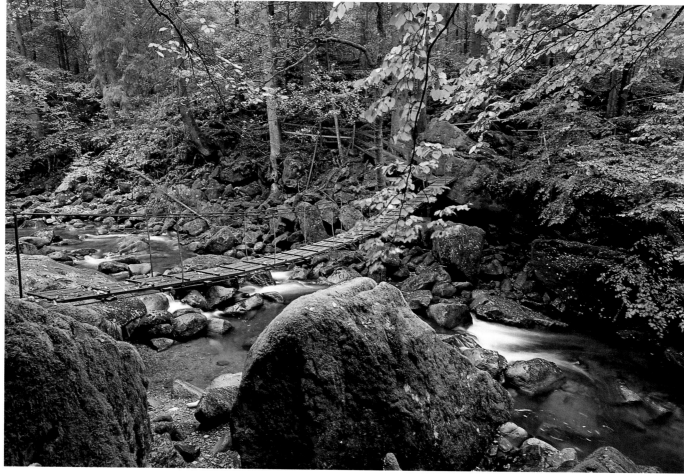

At the Finsterau open-air museum, enveloped by swathes of forest, many historical buildings such as this old farmhouse have found a new home. The museum provides visitors with an insight into the hard and deprived lives of the people who once lived here.

The Bayerischer Wald National Park is best explored on foot. There are thus 320 kilometres (198 miles) of well-sign-posted hiking trails between Bayerisch Eisenstein and Finsterau, with 170 kilometres (106 miles) of cross-country ski runs carved out of the snow in winter.

INDEX

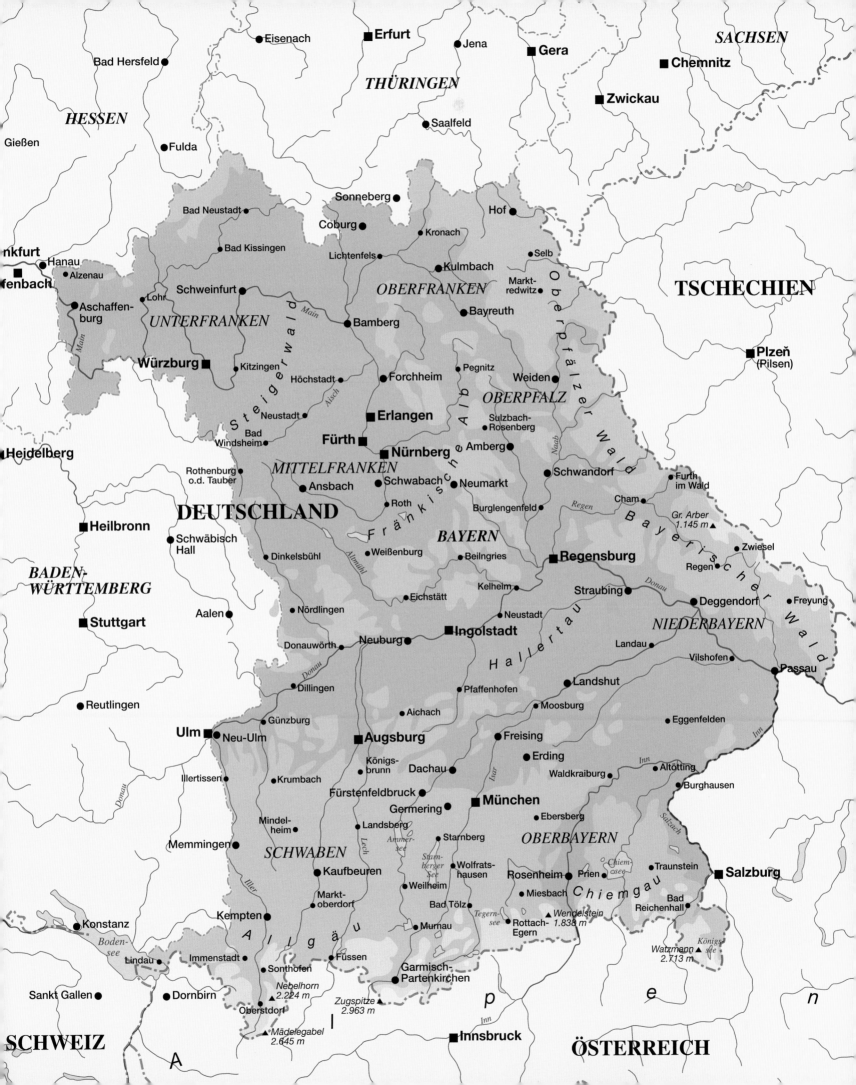

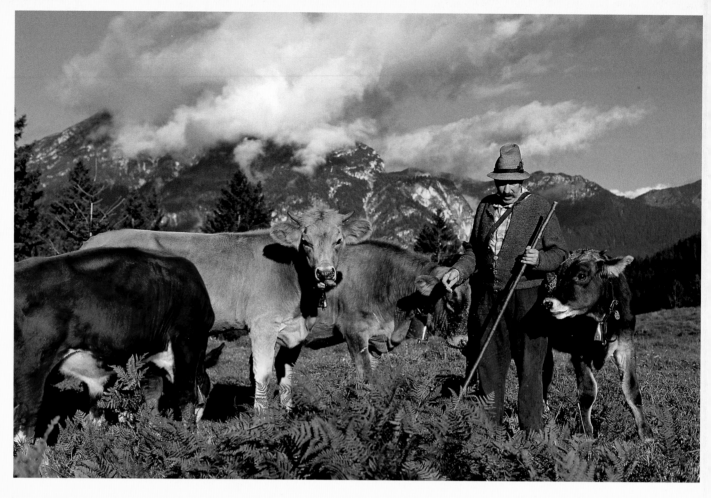

Even if it doesn't look like it the life of the Alpine farmer – such as here in the Werdenfelser Land – is anything but idyllic. Not so long ago life was simply a fight for survival in many places hereabouts.

Front cover:
Top:
In 1536 the Spezial brewery in Bamberg claimed that it was one of the oldest in town – a claim which still holds true today! Here visitors settle down to a litre Maß of the establishment's best brew at the Spezi-Keller which is open all year round.

Bottom:
The much-frequented fairytale castles of the East Allgäu also enjoy a wonderful setting on the Alpsee. Neuschwanstein (in the foreground) was the work of King Ludwig II of Bavaria, with Hohenschwangau beneath it built by his father.

Back cover:
Barley, hops, yeast and water are customarily the sole ingredients used in the making of Bavaria's most famous beverage: beer. The brewing process has been regulated by the German Purity Law for centuries – and still is, resulting in various brews which are clean, traditional and very tasty.

CREDITS

Design
hoyerdesign grafik gmbh, Freiburg

Map
Fischer Kartografie, Aichach

Translation
Ruth Chitty, Schweppenhausen

Printed in Germany
Repro by Artilitho, Lavis-Trento, Italy
Printed/Bound by Druckerei Ernst Uhl GmbH & Co. KG, Radolfzell am Bodensee
© 2007 Verlagshaus Würzburg GmbH & Co. KG
© Photos: Martin Siepmann

978-3-88189-664-1

Details of our full programme can be found at:
www.verlagshaus.com